Postcard History Series

San Bernardino

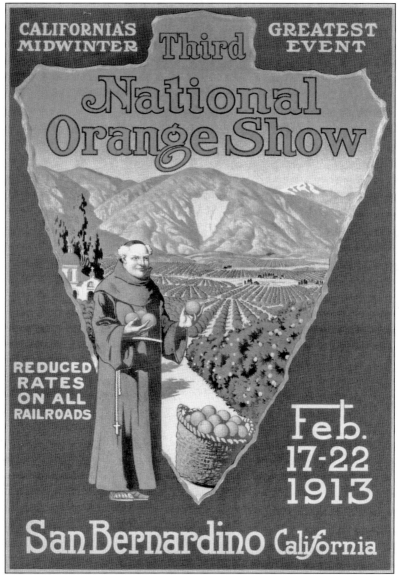

This newer postcard is a reproduction of a poster from the Third National Orange Show. It emphasizes the famous Arrowhead Landmark, the valley's citrus heritage, and the founding missionaries.

ON THE FRONT COVER: With the snow on Mount San Bernardino in the distance, it looks like another busy day on Third Street in the city of San Bernardino in the very early 20th century. Most of the city's businesses and the increasing number of hotels were on Third Street. With the completion of the Santa Fe Railroad in 1883, the population of San Bernardino quadrupled by 1900 to over 6,000. (Courtesy of Steven Shaw.)

ON THE BACK COVER: In 1902 in San Bernardino, the *Free Press* reported, "The electric cars are running on time and we are now strictly metropolitan." For the previous 17 years, mule-drawn trolleys were used. These passengers don't look in a big hurry to get moving. They must have had confidence the new system was quicker. (Courtesy of Steven Shaw.)

Postcard History Series

San Bernardino

Steven Shaw

Introduction by Patrick J. Morris
Mayor of the City of San Bernardino

ARCADIA
PUBLISHING

Copyright © 2007 by Steven Shaw
ISBN 978-0-7385-5581-2

Published by Arcadia Publishing
Charleston SC, Chicago IL, Portsmouth NH, San Francisco CA

Printed in the United States of America

Library of Congress Catalog Card Number: 2007931268

For all general information contact Arcadia Publishing at:
Telephone 843-853-2070
Fax 843-853-0044
E-mail sales@arcadiapublishing.com
For customer service and orders:
Toll-Free 1-888-313-2665

Visit us on the Internet at www.arcadiapublishing.com

*This book is dedicated to the men who started the
San Bernardino Society of California Pioneers in 1888.
Today at the City of San Bernardino Historical and Pioneer Society,
we are striving to carry on their original objectives to collect
and preserve the past.*

Contents

Acknowledgments		6
Introduction		7
1.	Early San Bernardino	9
2.	Railroads and Hotels	19
3.	City Parades, Festivals, and Fairs	35
4.	Public Buildings	43
5.	Plentiful Water for Parks and Home	71
6.	Arrowhead Springs	85
7.	The National Orange Show	99
8.	Route 66 and Beyond	117

ACKNOWLEDGMENTS

I would like to acknowledge all the people that made it possible to put this book together. Knowing they were there to help inspired me to start this project.

First I would like to thank Patrick Morris, mayor of the City of San Bernardino, for endorsing this project and writing the introduction. Mayor Morris has a genuine appreciation of the city's history and realizes the importance of preserving it for future generations. Thanks also to Emil Marzullo, assistant to the mayor and longtime San Bernardino resident, for his editing advice. Special thanks to my editor, Debbie Seracini from Arcadia Publishing in San Diego, for her time, effort, and input.

I would also like to acknowledge fellow historians and board members of the City of San Bernardino Historical and Pioneer Society, Allen Bone, Nick Cataldo, Gregg Gridley, and Richard Thompson, for their vast knowledge of this city we all grew up in.

I especially want to thank Tom Marek, director of information technology for the City of San Bernardino, for his editing help with the book and also all he has done to create a much larger public interest in the city's history through the city's Web site. The Historical and Pioneer Society has benefited in many ways with the society's page on the city's Web site at www.ci.san-bernardino.ca.us

I also want to thank the publishers of the postcards used in this book. Thanks to them, we have a much better photographic historical record. The images they created were usually accurate in depicting the life and times of our past generations.

Finally, I wish to thank my wife, Gail, for her never-ending support of my passion to preserve the history of San Bernardino.

All postcards used in this book come from the author's personal collection, unless otherwise noted.

INTRODUCTION

One hundred and ninety-seven years ago, Fr. Francisco Dumetz set out from Mission San Gabriel to explore the valley to the east. He made camp at the base of the mountains near a natural passageway to the desert beyond. The passage he called *cajon* (the drawer through the mountains). There he built a modest *capilla* (a chapel) honoring St. Bernadine de Siena on that saint's feast day, May 20, 1810.

Returning to Mission San Gabriel, he told the mission fathers that the beautiful valley to the east would be named San Bernardino. He wrote in his diary, "The valley is fertile and there is an abundance of water, both from the springs in the lowlands and from stream-flow from the mountains to the North and East. The Valley will be found one-day's march east of here and is easily located by a mark on the mountain. This mark is in the shape of a large arrow, after the fashion used by Indians of the region. At the base of the mark is found a hot spring and some mud sinks, the hottest water that I have ever seen issuing from the earth."

To pasture their cattle and convert local natives, the fathers of Mission San Gabriel established Rancho San Bernardino and constructed estancia buildings along a river they named Santa Ana. In 1842, with the demise of the mission system, Don Antonio Maria Lugo, former mayor of Pueblo de Los Angeles, purchased Rancho San Bernardino from the Mexican government for $800 in hides and tallow.

Nine years later, following stories told by frontiersmen about the beauty of the San Bernardino Valley, a wagon train of 500 Mormon pioneers from Salt Lake City came through the *cajon* intending to settle the valley. They purchased Rancho San Bernardino from Don Lugo for $77,000. The site now occupied by the present county courthouse was selected as a place for a permanent settlement because of the abundance of grass and water and its location below the great mountain pass. Thus was established the oldest incorporated city east of Los Angeles.

Over the past 156 years, tens of thousands of settlers have arrived in this city and stayed. They built homes, businesses, churches, and schools on the grasslands; controlled the waters; and took advantage of the location at the base of the mountain pass to become the transportation hub of Southern California. The reputation of the city grew as a hard-working center of business and industry and the seat of government of the nation's largest county, and it prospered. Eight generations of settlers have raised their families and lived out their days here. They spent their lives and fortunes weaving the fabric of the community, and many now lie beneath its sod.

As the city approaches its bicentennial in 2010, it is fitting that we celebrate our past and dedicate ourselves to the future of this historic city, now populated by over 200,000 residents. One of the unique opportunities for historical storytelling is through the eyes of postcard

photographers and the words of those who through the years sent greetings to friends and relatives. All will enjoy this special publication, researched and authored by Steven Shaw, president of the City of San Bernardino Historical and Pioneer Society.

Poets, like photographers, capture the mood in a moment of time. So it was at my inauguration as the 27th mayor of the City of San Bernardino in 2006 that Michael Arnold offered this poetic reflection on our past and a resolve for all of us who care about our city's future.

Under the white arrowhead, against the green,
Where the flatland rises to meet the hill,
Where once the tribes traversed their own wide lands,
And where the padres came to bless and build,
There grows the city, San Bernardino.

A city of good lineage and good bones
And lest we forget, a hard scrabble town
Where men came whooping down from gold-rich
Bear and Holcomb Valleys for riotous, red light nights
Thereby setting something of a trend.

Now is a time of dedication,
Of hope, of plans, or optimism,
Of bold deciding what this city,
Almost on a hill, should strive to be.

She first should be abundantly alive;
Her streets, schools, stores, should hum with energy,
For life renewed is each tomorrow's pledge.

She should be safe, so that all might move about
In every public place as if at home,
For fear can bring a city to a living death.

She should be a place of constant learning,
For all, both young and old, have constant need
Of self-sustaining, self-regeneration.

She should have music and theater,
Open space for sport and competition,
For life lacking stimulus is not real life.

Above all, she should have men and women
Of high ethics and heroic hearts to lead;
For a venture that is stricken at the head
Is condemned to wither at the root.

She should have aid from all her citizens;
The city is not just brick and stone,
The city, at her heart, is people.

—Patrick J. Morris
Mayor, City of San Bernardino

One
Early San Bernardino

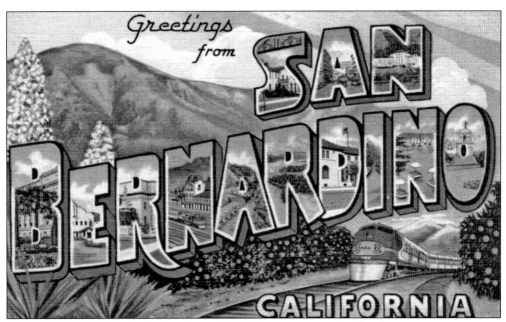

This big-letter postcard from the 1960s has a different scene from San Bernardino in each letter. The S is the junior college, the A is E Street, and the N is Arrowhead Hot Springs. The B is the courthouse, the E is the Orange Show, the R is the municipal auditorium, the N is the Santa Fe depot, the A is the Rim of the World Highway, the R is Big Bear Lake, the D is the post office, the I is orange groves, the N is Lake Arrowhead, and the O is the San Bernardino Asistencia.

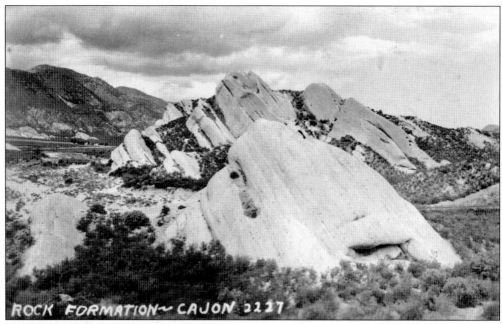

These sandstone rock formations, created by compression and shearing along the San Andreas Fault, are simply called the Mormon Rocks. They were named for the Mormon pioneers and freighters who camped near here after completing their trip across the Mojave in 1851 on their way to San Bernardino. Two years later, in 1853, the County of San Bernardino was formed. In 1854, the city of San Bernardino was first incorporated.

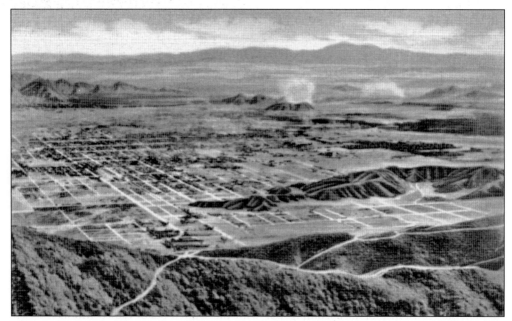

This view of the San Bernardino Valley is east of where the Mormon pioneers would have seen it in 1851 from the mountains of the San Bernardino National Forest. The image does give a good idea of the first impression the pioneers got of the lush and fertile valley without, of course, the grid lines made by the streets in this image.

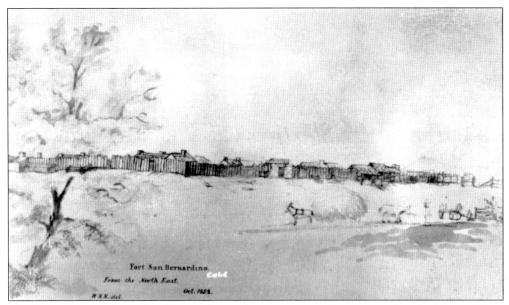

The first white settlers in San Bernardino built the Mormon Stockade or Fort San Bernardino. It was built shortly after they arrived in 1851 for protection from the Native Americans, who were thought to be hostile. Over 100 families lived inside the 12-foot-tall walls that were made of logs from local cottonwood trees. There was never an attack on the fort, and the settlers moved out and began laying out the new town.

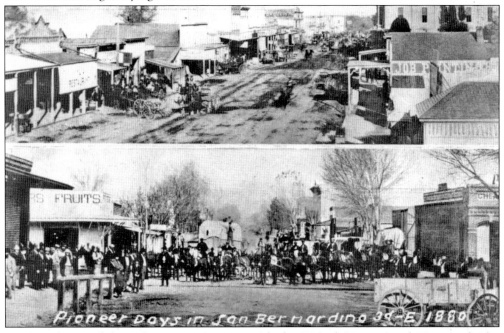

In 1857, the possibility of an upcoming war with the United States caused Mormon leader Brigham Young to recall the Mormon pioneers of San Bernardino back to Salt Lake City. Some of them stayed, some returned after a few years, and some kept their businesses that brought them back occasionally. Gold was discovered in 1860 in nearby Holcomb Valley. All of these factors turned San Bernardino into a typical Wild West town, as seen here in the 1880s.

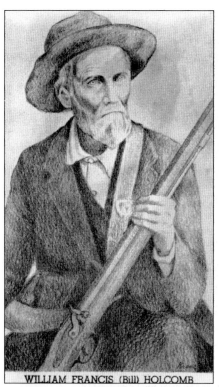

WILLIAM FRANCIS (Bill) HOLCOMB

In 1860, William F. Holcomb, or "Uncle Billy" as fellow pioneers called him, came to San Bernardino. He discovered gold in nearby Bear Valley and Holcomb Valley. He held two different county offices from 1871 until the late 1880s. He was one of the founding members of the San Bernardino Society of California Pioneers. Former San Bernardino mayor W. R. "Bob" Holcomb is the great-grandson of this pioneer.

Above the door and windows of this old stagecoach reads "San Bernardino & Los Angeles 1854." A circular printed in 1877 by Wells Fargo advises, "Don't lag at the wash basin or grease your hair because travel is dusty. Don't imagine for a moment that you are going on a picnic. Expect annoyances, discomfort and some hardship."

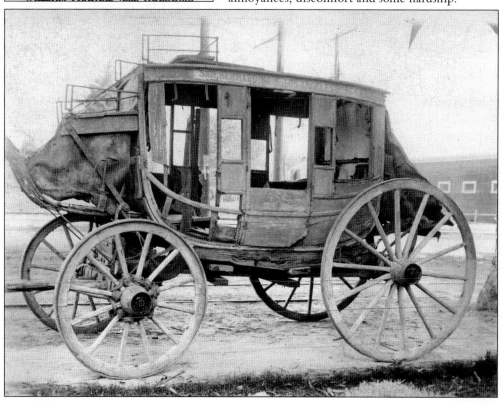

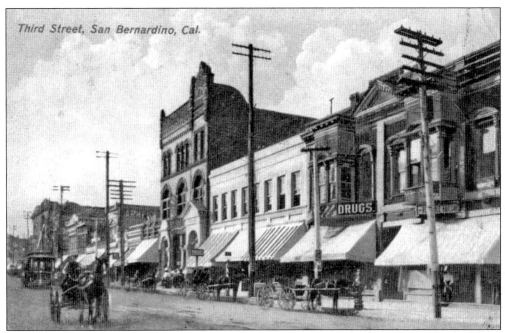

Third Street was the major street in the city for many years. The three-story building is the Farmers Exchange Bank built in 1888. In 1919, the city purchased it for $40,000. It contained all general government officers—street department, police department, and water department—and housed the U.S. Forestry Department. It was used as the city hall until 1938.

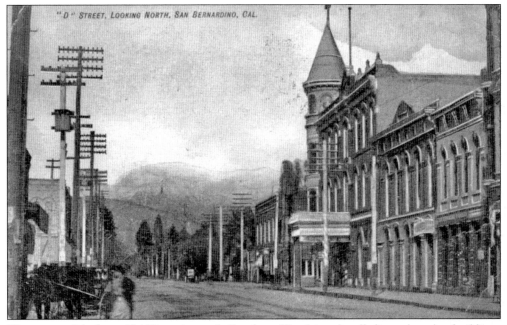

The turret of the beautiful Victorian-style Southern Hotel stood well above the other buildings on D Street. It was made of brick and built in 1874 on the southeast corner of Fourth and D Streets, replacing the city's second hotel, the Bella Union. The Bella Union was a two-story adobe built in 1857.

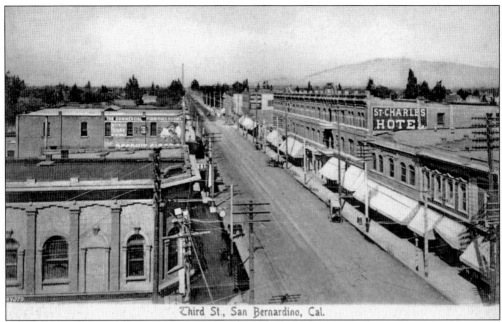

John Andreson came to San Bernardino in 1871 and built a brewery shortly thereafter. He sold it in 1884. The three-story brick building that reads St. Charles Hotel was the first Andreson Building. Built on Third Street in 1887, the brick building was said to be the best in the city. Offices and stores occupied the ground floor. The hotel had 80 rooms.

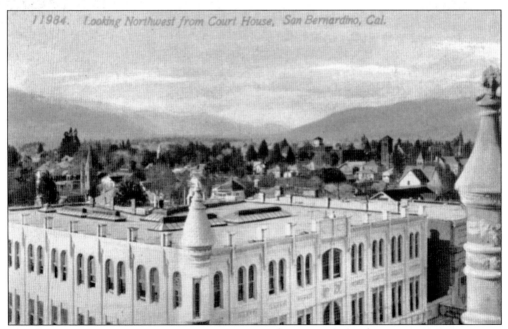

In 1888, Andreson became partners with H. L. Drew. This was a time of rapid growth in the city's history. The city's post office grew too large for the Masonic Temple building. Drew and Andreson's first structure was at Court and E Streets. It was especially constructed to house the post office and was boasted to be the most complete and modern in Southern California.

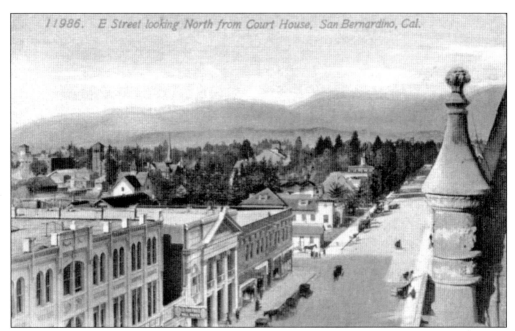

The Post Office Block is shown on the far left with the Masonic Temple next door, which was built in 1903. The view is looking north on E Street from the second county courthouse located at Court and E Streets. Construction of the courthouse was completed in 1898.

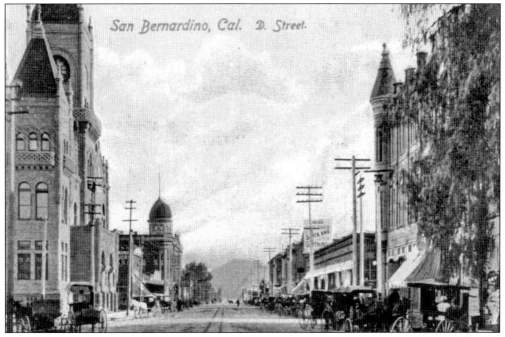

The top of this postcard falsely identifies this image as D Street in San Bernardino, California. The buildings shown locate the view on E Street, looking south with the courthouse and the Post Office Block across the street from one another at Court and E Streets. The turret shown down the street on the left is the Stewart Hotel, which was at Third and E Streets.

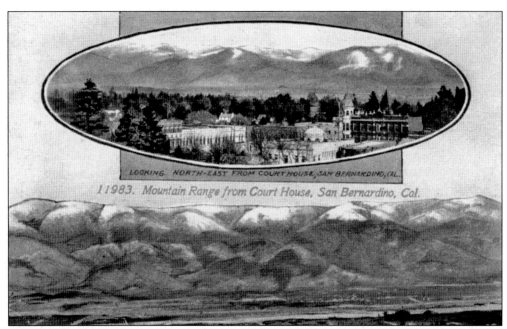

The combined aerial views of San Bernardino show a wide shot of the San Bernardino Mountains and Valley and a closer view looking northeast from the courthouse in the early 1900s.

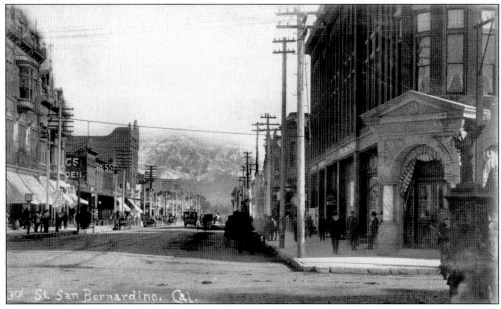

In the late 19th and early 20th centuries, there was a large, ornate fountain with a winged angel holding a harp at Third and E Streets across from the Stewart Hotel. The low snow level on Mount San Bernardino, looking east on Third, happens only a few times each winter. It appears to have snowed the night before. The mule-drawn trolley can be seen down the block.

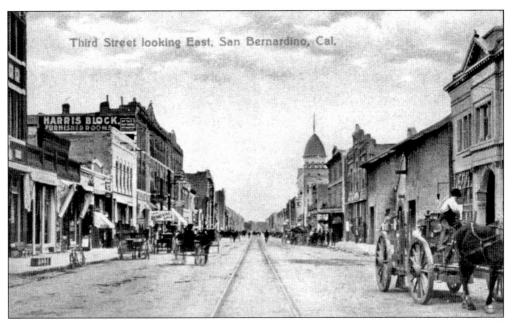

There were many places to get a room on Third Street in the early 20th century. Looking east from about F Street in front of the Sunset Hotel, the turret of the Stewart Hotel can be seen down on the right. The building with the sign Harris Block advertises "Furnished Rooms." The tallest structure on the left is the St. Charles Hotel, and across the street is the Commercial Hotel.

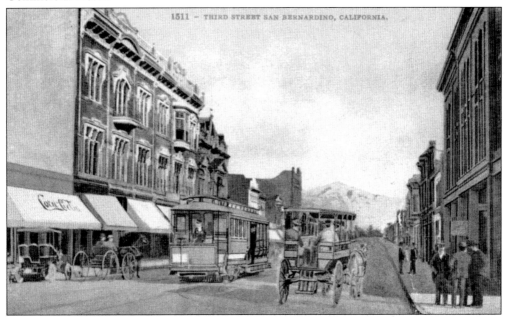

The electric trolley was introduced in the city in 1902 by the San Bernardino Valley Traction Company. The city had three newspapers at the time and each one heralded their debut. On February 24 that year, the *Free Press* reported, "The electric cars are running on time and we are now strictly metropolitan." Around that time, Coca-Cola supplied pharmacists with clocks, urns, calendars, apothecary scales, and obviously awnings bearing the Coca-Cola brand.

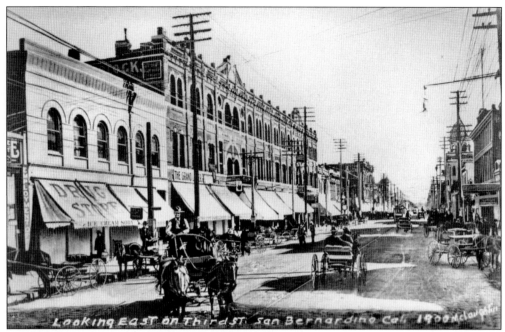

This view looks east on Third Street around 1900. The city was starting to get modernized, with electric lights and all the telephone poles that came with them, but it still had dirt streets and horse-drawn wagons and buggies. The city has always had wide streets that were originally laid out by the Mormons, but it looks like a tight squeeze for traffic when the trolley came through.

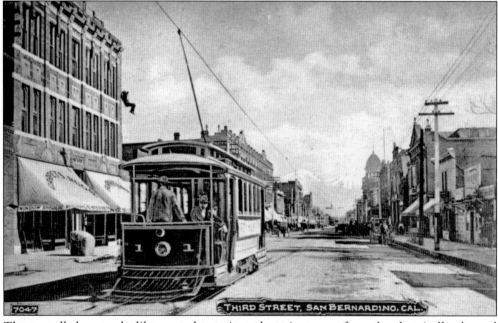

The car rolled on tracks like any other train and got its power from the electrically charged wire suspended above. The car was connected to the wire by a pole extending from the roof called a "trolley." Sadly, years later, the cars were replaced by gas-powered buses.

Two

Railroads and Hotels

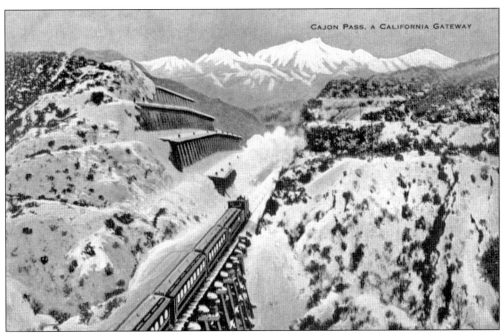

The Cajon Pass is the gateway into San Bernardino and Southern California from the Mojave Desert. In the mid- to late 1700s, Spanish explorers named it *cajon*, meaning "box," because of the steep walls. It was a major obstacle for the railroad in the 1870s and 1880s. This image appears to be near the summit.

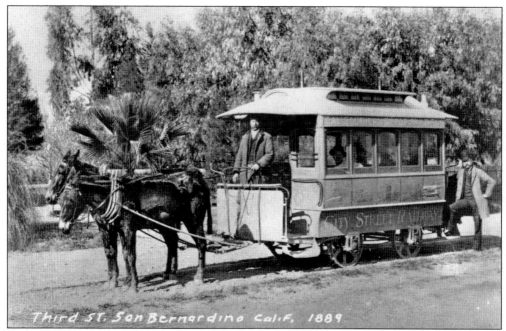

The City Street Railway started in 1885. The car traveled up and down D Street and along Third Street. Mules were used to haul the car. The driver, shown in 1889, is Lucas Westhoff. In modern terms, it would seem pretty slow, but was probably perfect for the citizens of that era.

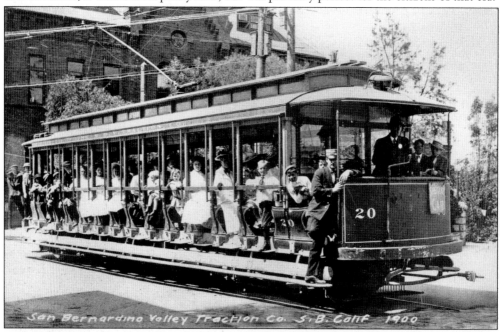

Henry Fisher and A. C. Denman Jr. started the San Bernardino Valley Traction Company in 1902. A rheostat controlled the electric car's speed. It was also equipped with an air-brake system to slow or stop the wheels. The first accident occurred on the first run of car No. 1. The second accident occurred on the second day with car No. 2. The service later improved despite the rough start.

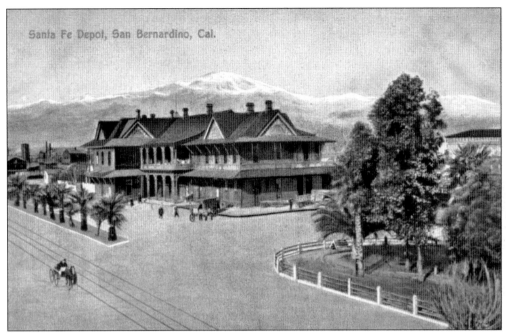

In September 1883, the first train whistle blew in San Bernardino. The Santa Fe Railroad got through physical obstacles caused by the terrain and legal obstacles caused by opposition by the Southern Pacific Railroad, which had service in the area already with a depot in nearby Colton. The first permanent depot was this wooden structure, built in 1886.

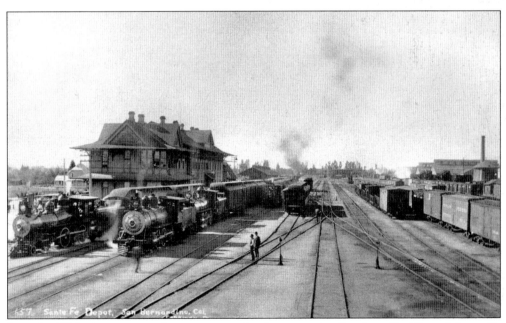

In early 1886, the rate war that was occurring between the Southern Pacific and Santa Fe Railroads for travel to the West Coast reached its climax. On March 6, for one day only, rates dropped to $1. California became flooded with tourists, and the boom was on. This view shows the many tracks coming into the north side of the depot about 1905.

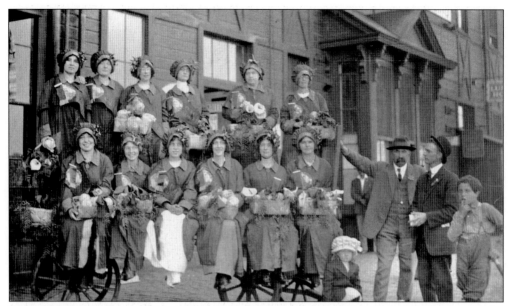

These women on the trackside of the Santa Fe depot are probably welcoming visitors to the First National Orange Show in 1911. They are all holding baskets of tissue-wrapped oranges and wearing pennants that read "San Bernardino." Unfortunately, the ribbons they're wearing cover the logo. The depot was destroyed by fire at 11:00 p.m. on November 16, 1916. (Courtesy of Dave Rutherfurd.)

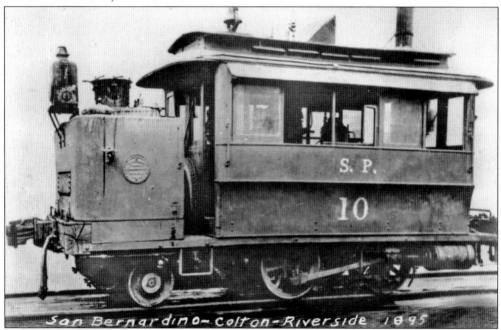

In 1886, a motor line was built connecting Colton to San Bernardino. It was extended to Riverside and finally Redlands in 1888. In 1892, the Southern Pacific Railroad purchased the lines. This locomotive was used between San Bernardino, Colton, and Riverside. In 1904, the Southern Pacific built a small depot near the center of town on the south side of Third Street between E and F Streets.

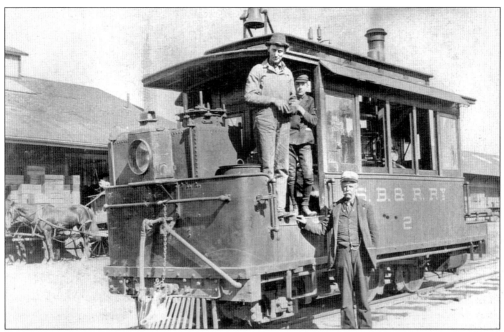

The motor line of 1888 from San Bernardino to Redlands reportedly was a most important factor in the early growth of Redlands. A roundhouse fire destroyed the first two locomotives in 1893. This is one of the replacements after 1900. This narrow-gauge railway cost 30¢ for a one-way trip and 50¢ for a round trip. Due to its size, it was called the "Redlands Dinky."

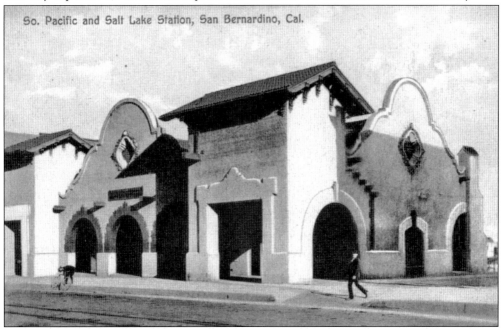

In July 1905, the Southern Pacific Railroad built a new depot on the spot of the one built in 1904 on Third Street between E and F Streets. Mission-style architecture with a large facade was used to keep the single-story depot from appearing dwarfed by the surrounding buildings. The old one can be seen on the top on page 17, the second building down on the right.

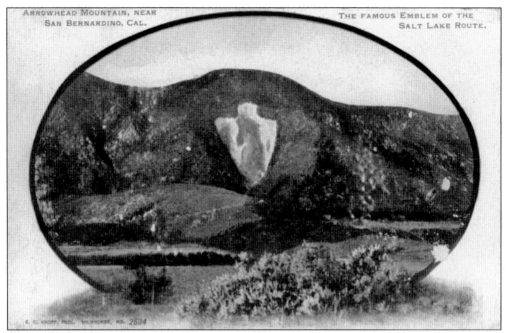

The Salt Lake Route was the line that ran between Salt Lake City, San Bernardino, Los Angeles, and the Pacific Ocean. It was advertised as a romantic journey with views of Nevada's mountains and canyons equaled only by the scenic charms of Southern California. San Bernardino's famous Arrowhead became the Salt Lake Route's emblem.

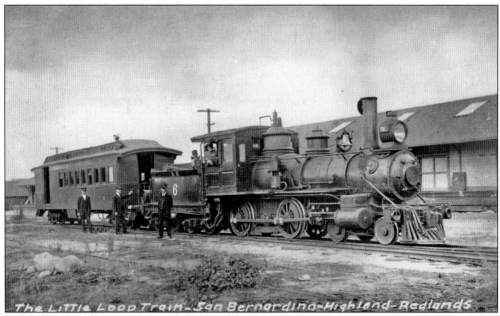

This small train, nicknamed the "Little Loop Train," ran on part of the Kite Shaped Track in 1893. This Santa Fe line was in the configuration of a figure eight with a large loop and a small loop. San Bernardino was the center point in the two loops, with the large loop going to Los Angeles and neighboring cities. The small loop from San Bernardino went through Highland and Redlands.

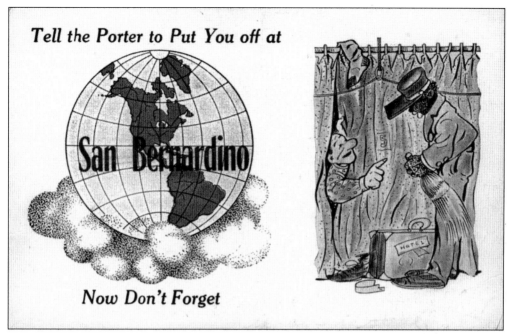

It isn't known if this promotional postcard, mailed in 1913, was successful at changing anyone's destination. At least the cards were probably free. San Bernardino's first depot, built in 1886, was destroyed by fire at 11:00 p.m. on November 16, 1916.

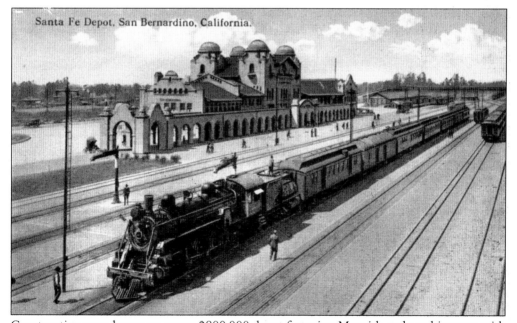

Construction soon began on a new $800,000 depot featuring Moorish-style architecture with domes, towers, and a tile roof. Opening on July 15, 1918, the *San Bernardino Sun* reported that the new depot would be a "monument to the Santa Fe and the town the railroad built. . . . Santa Fe's new station to be the finest in the West. . . . Credit to San Bernardino showing importance of the Gate City as a transportation center."

Between 1917 and 1918, the Santa Fe spent over $1 million for construction of additional shop facilities and the extra property needed for the expansion. In 1922, a huge machine shop was built. It was equipped with an overhead crane that could lift even the largest locomotives made.

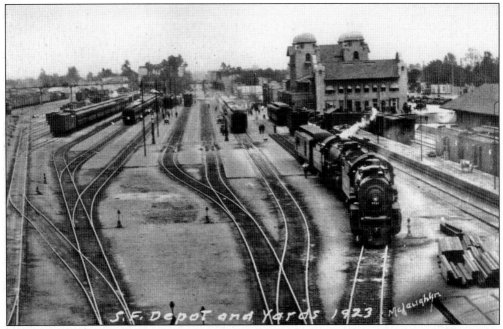

In 1921, there were approximately 40,000 cars of citrus fruit alone shipped out of the depot. Each car held 448 boxes of oranges weighing 78 pounds each, equaling close to 35,000 pounds of oranges per car. All of it needed to go through Santa Fe's pre-cooling plant to be able to remain fresh on its way to market on the East Coast.

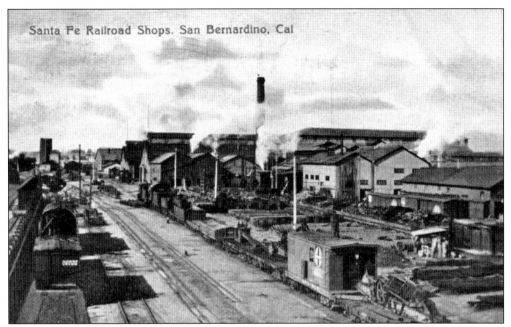

The powerhouse and smokestack were erected in 1923 and were powered by two boilers. A new steam whistle replaced the one used since the 1890s. It blew nine times daily for the workers' breaks, lunch, and so forth with 60-second blasts. The whistle could be heard throughout the city and became a welcome reminder of the time of day. Although most of the shops are gone, the smokestack and whistle are preserved.

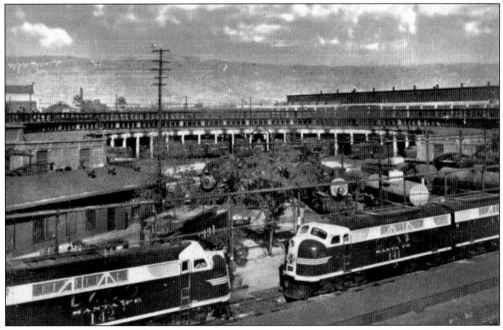

The 1940s saw the introduction of diesel locomotives. These classic twins were built in the 1950s and are posed with the roundhouse and the San Bernardino Mountains in the background. The roundhouse was the largest in the Southwest when it was built in 1908 at a cost of $150,000.

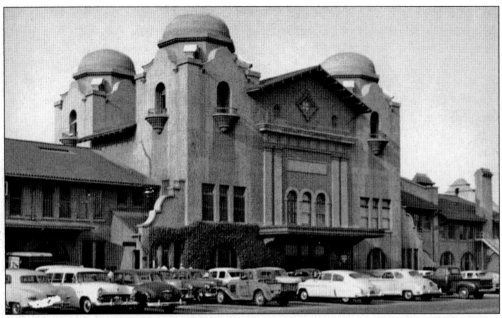

The exterior of the depot, with its domes, towers, and a tile roof, is only part of its beauty. Inside lofty beams and recessed ceiling panels are classically decorated. In 2004, restoration was completed, and it now serves Metrolink, a commuter rail service; Amtrak; and houses the offices of the San Bernardino Associated Government (SANBAG), a council of governments and transportation planning agency for San Bernardino County.

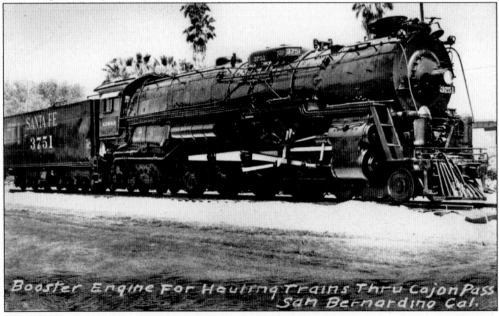

The Santa Fe used No. 3751 from 1927 until 1958, when it was put on display in Viaduct Park next to the San Bernardino Depot. In 1985, it was sold to the San Bernardino Railroad Historical Society for $1. The fully operational restoration was completed in 1991 and is a huge attraction when it's steamed up. It now has no permanent home but hopefully will soon come back to San Bernardino.

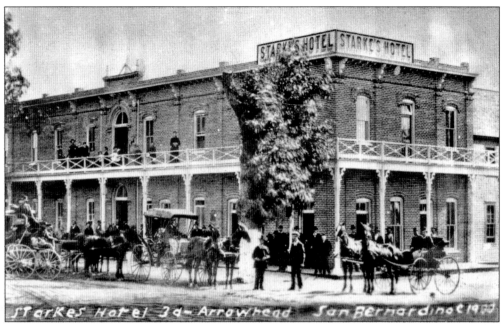

Starke's Hotel was on the corner of Third Street and Arrowhead Avenue. This two-story brick hotel was built in 1880. The Pine's Hotel was originally on the site, built in 1858. August Starke bought that hotel and, in 1870, added an adobe wing of 25 rooms. For many years, Starke's Hotel was the place to go for social gatherings in San Bernardino.

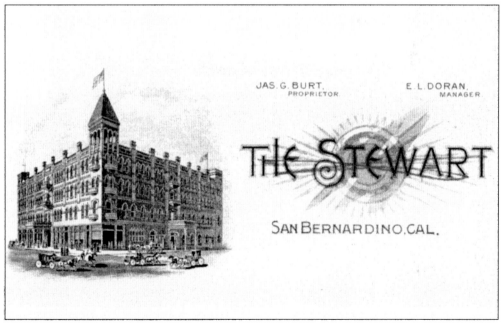

Built by John Henry Stewart, this magnificent, four-story Stewart Hotel was built in 1887. This pioneer resident tragically died before its completion. It was said to be the finest hotel south of San Francisco and was 150 feet square with a courtyard in the middle. With 400 rooms, it was probably the finest hotel San Bernardino ever had, but it burned to the ground in 1892.

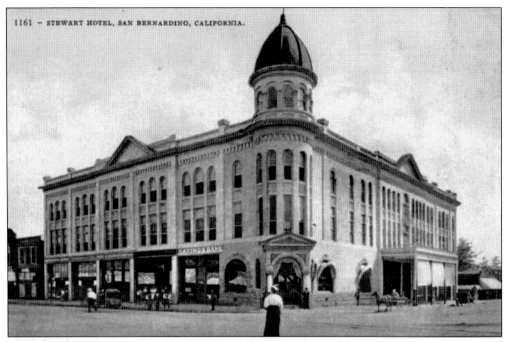

The new, downsized Stewart Hotel replaced the original in 1893. At three stories, the second hotel was less costly but was still one of the most comfortable and well-run establishments in San Bernardino for years.

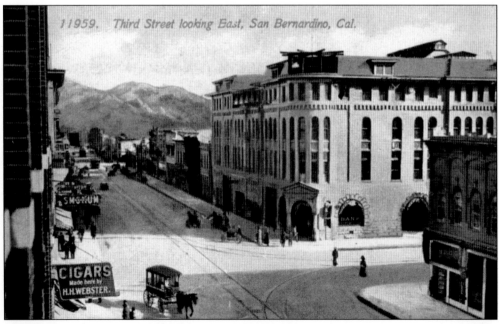

By the early 1900s, the beautiful turret was gone for reasons unknown, although fire is probable. The arched dome was replaced with this odd-looking structure resembling a ship's wheel if viewed from the top. In keeping with its history, this one burned down on Thanksgiving Day in 1935.

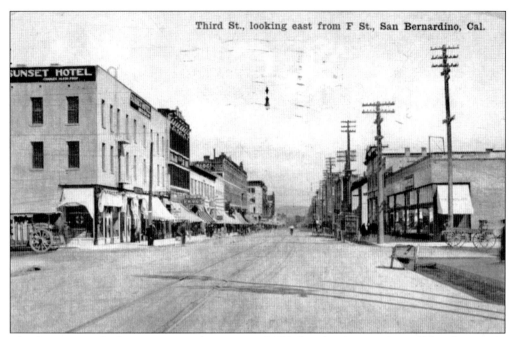

The Sunset Hotel, shown, was on the corner of Third and F Streets. A small hotel entrance was on the first floor with access to the second and third floors. Offices of the Santa Fe, a barbershop, a fruit market, and a photography shop were located downstairs.

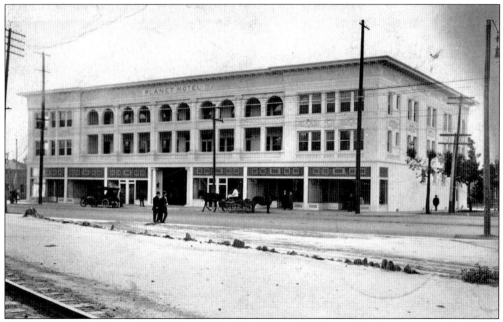

In the early 1900s, railroad travel was booming. A number of hotels had to be built to accommodate the huge migration of people coming from the East Coast. The Planet Hotel, shown, was on Third Street west of I Street. It was walking distance from both the Santa Fe and Southern Pacific depots.

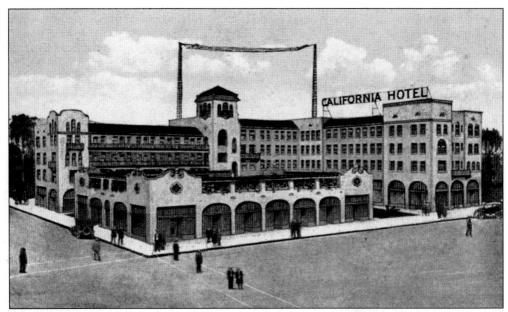

The California Hotel was built in 1927 on the corner of Fifth and E Streets. With its many rooms and close proximity to everything downtown, it was a popular destination for travelers. Surrounded by palm trees, it is reminiscent of the Eagles' song "Hotel California." Shops and offices were located in the large, single-story building directly on the corner. Sadly it was demolished in 1985.

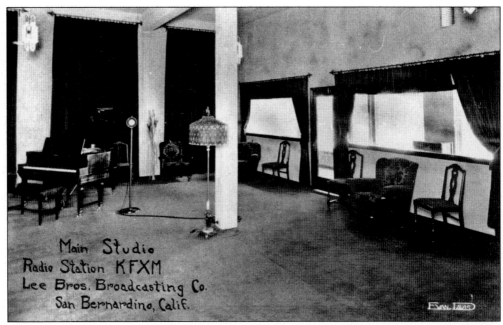

The KFXM Radio Studios were located in the office and shopping complex on the corner of the California Hotel. KFXM is San Bernardino's oldest radio station and still broadcasts today. Ernie Ford made his debut as "Tennessee" Ernie at that station from March 1946 until November 1947.

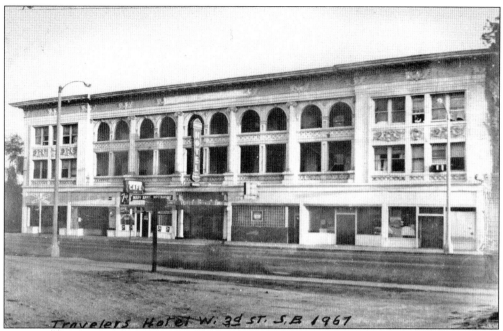

The Travelers Hotel was another hotel built to accommodate the large number of travelers coming to San Bernardino by train. Like so many of the hotels, it was on Third Street within walking distance to both depots and downtown stores, theaters, and restaurants.

The Hotel Byron was located across from the courthouse at Court Street and Arrowhead Avenue. The Spanish style was the same as so many of the buildings of that era. Shops were located on the ground level, and the hotel rooms were upstairs. It promoted itself as "air cooled, strictly modern, steam heat, etc."

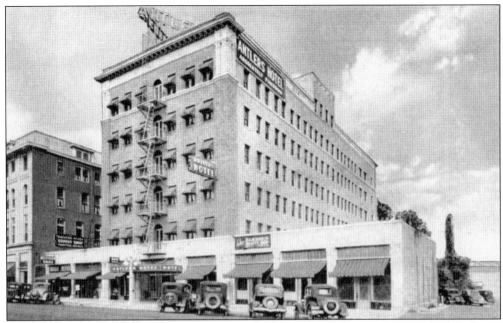

The Antlers Hotel was located on E Street between Second and Third Streets. The painted sign on the side states that it is "Strictly Fireproof." That was probably a good thing to promote, given the fate of the nearby Stewart Hotel and many other buildings in the city's history.

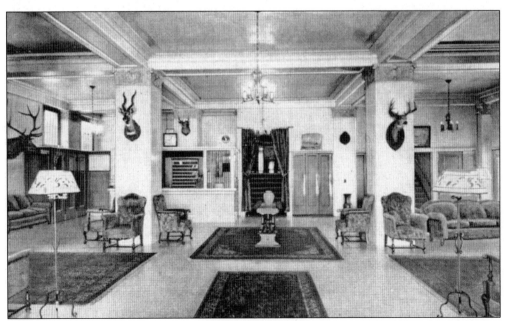

Which came first: the name Antlers Hotel or the lobby decorations? This beautiful lobby looks like a great place to meet fellow travelers and make plans for the day. The hotel was located in the heart of the thriving downtown area. In those days, many people came to San Bernardino just to shop and go to the theater.

Three

City Parades, Festivals, and Fairs

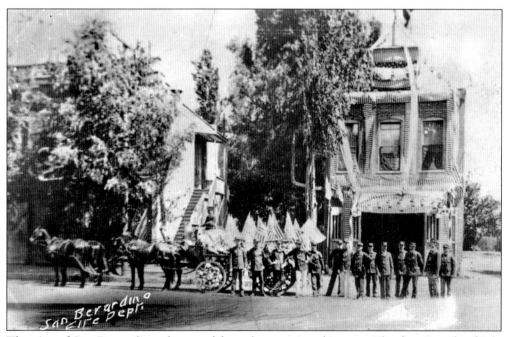

The city of San Bernardino always celebrated events in a big way. The first Fourth of July celebration occurred in 1853. Pioneer John Brown went all the way to Fort Tejon to secure a flag and a cannon, which were brought from Los Angeles by pioneer John McDonald. This image shows the fire department covered with bunting, banners, and flags for the Fourth of July in 1894. Just two horses usually pulled the hose wagon, but for the celebration, four horses were hitched.

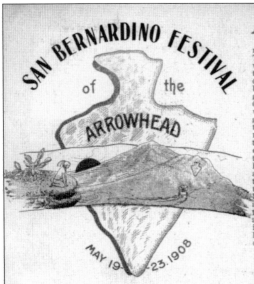

A Legend of The Arrowhead

In the days of long ago, the Cohuillas dwelt across the mountains to the southward near the San Luis Rey Mission. They were continually harassed by their warlike neighbors, who stole their ponies, devastated their fields and burned their jacales. For many years they lived unhappy and in constant fear, until at last the persecutions could no longer be endured, and at command of their chief, the tribesmen gathered in council for the purpose of calling upon the God of Peace to assist and direct them to another country, where they might acquire a quiet home land. Now being a gentle people, so the tale runs, they found special favor with the Great Spirit, by whom they were directed to travel northward, and instructed that they would be guided to their new home by a fiery arrow, for which they must be constantly watching. Accordingly the tribe started upon the journey, and one moonless night when the camp sentries had been posted with usual injunctions to be watchful, there appeared across the vault of heaven, a blazing arrow, which took a course northward, settling upon the mountain, where the shaft was consumed in flame, but the head imbedded itself, clear-cut, in the mountain side. The camp was aroused, and while yet the morning star hung jewel-like in the sky, and a faint gleam of light in the east heralded the approach of day, they resumed their journey to the promised land, under the shadow of the mountain, where they located and lived in peaceful contentment until the coming of the white settler.

A Festival of the Arrowhead street fair was held in May 1908 to promote the Southern California lifestyle in San Bernardino, the "Gate City," and to highlight San Bernardino Valley's rich resources. The Arrowhead was Mother Nature's way to point out this rich valley. According to the *Sun*'s souvenir publication, the four-day, five-night fair transformed the city into a "great guest house by day and a fairyland by night."

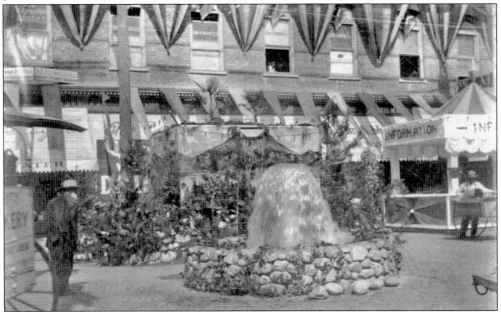

This artesian well was actually made by the water department in the middle of E Street. The entire city was decorated with colorful flags and banners and so many lights for the Festival of Arrowhead that it made "day of the night," according to the *San Bernardino Evening Index* souvenir program. Six huge parades were held, with hundreds of entries from San Bernardino and surrounding cities that included dancing girls, bands, bicycles, horses, horse-drawn wagons, and the new automobiles.

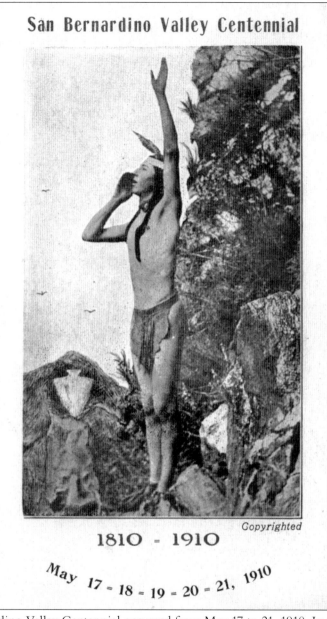

The San Bernardino Valley Centennial occurred from May 17 to 21, 1910. In the early 1800s, pastoral outposts of Mission San Gabriel were being established in areas near Native American settlements. Fr. Francisco Dumetz was a Franciscan priest living in semi-retirement at Mission San Gabriel after a distinguished career of 40 years. On May 20, 1810, he arrived here and named the valley for St. Bernadine of Siena, a great Italian missionary of the late 14th century who is the Catholic patron saint of that day. He had no idea that name would eventually be used for a county, a city, a mountain, and a mountain range. Due to the demise of the California mission system and loss of many records, present-day researchers have been unable to prove or disprove this event ever occurred on that date. However, as early as the mid-1820s and the 1830s, "Bernardino" was printed on maps of the area, and the story became a part of mainstream history.

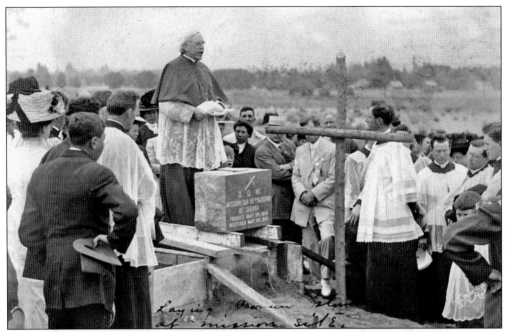

Bishop Thomas James Conaty of Los Angeles conducted the ceremonies at the laying of the cornerstone for the proposed *capilla* or chapel to be built on the site where Father Dumetz first named San Bernardino. The *capilla* was to replicate the first mission but was never built. After being moved to several areas, the stone is now safe at the Historical and Pioneer Society to be reset in 2010 for the bicentennial.

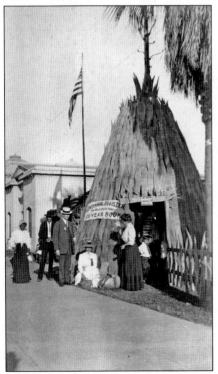

Organized in 1888, the San Bernardino Society of California Pioneers was the predecessor of the currently active Historical and Pioneer Society. They always took a large role in city events. For the San Bernardino Valley Centennial Celebration, they built a wikiup or wigwam using the long leaves of a century plant, also known as an agave cactus. Also built was a log cabin that is hidden in this image.

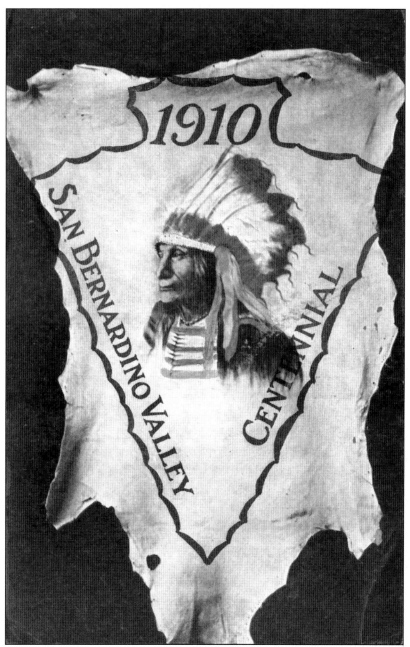

The earth was passing through the tail of Halley's Comet at the same time the San Bernardino Valley Centennial was being held. On May 19, 1910, the *San Bernardino Sun*'s headline was "Centennial Eclipses Comet." One columnist wrote, "That meteoric demon of the heavens himself could not have attracted the throng that gathered to witness the continuation of the legendary scenes of long, long ago." Every city in San Bernardino County participated in the Centennial Celebration. The *Evening Index*, another local newspaper, printed a 128-page book about the event. If the 2010 Bicentennial Celebration is half as big, it will be a huge success. This card depicts a Native American chief, most likely of the Serrano band of Mission Indians who were the original habitants of the valley.

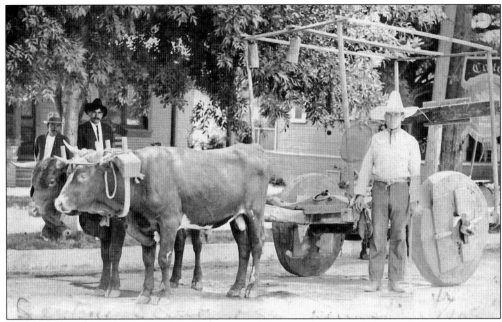

Livestock was still very important in 1910 for transportation of people and goods—so important that a separate parade was held for the stock. The celebration also had a theme of depicting life the way it was 100 years before. Costumes were worn that portrayed the Native Americans, Spaniards, Mexicans, and pioneers.

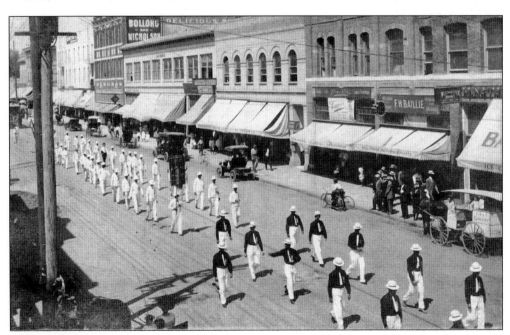

Many of the hundreds of parades held in the city were on Third Street. This Labor Day parade was held in the early 1900s just after automobiles were introduced. The City Bakery wagon, on the far right, was still horse-drawn. The men in the second group must have realized it was their last day to wear white that year.

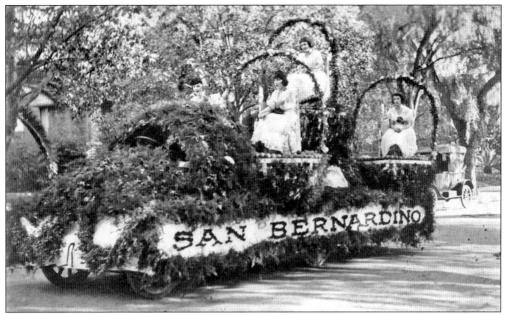

The City of San Bernardino had about 50 appearances in the history of the Pasadena Tournament of Roses Parade, including the National Orange Show floats. This is not including six appearances by the restored San Bernardino Fire Department horse-drawn hose wagon since 1997. The hose wagon (page 45), owned by the Historical and Pioneer Society, was in the group representing the California State Firefighter's Association. The image shown was taken in 1921.

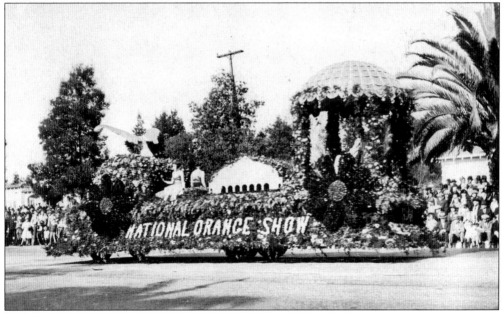

The National Orange Show, which started in San Bernardino in 1911, became synonymous with San Bernardino, like the Rose Parade is synonymous with Pasadena now. The onlookers at this 1920s Rose Parade knew that the float was from San Bernardino even if it didn't say it. Like the Rose Parade, every year the National Orange Show has a queen and her court.

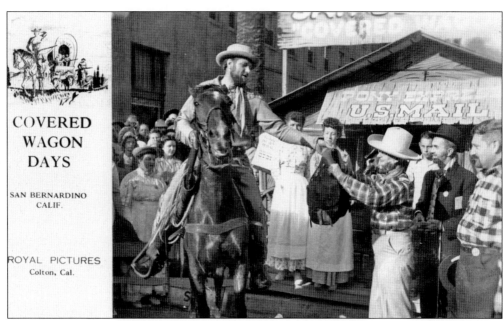

From the 1930s until the 1950s, San Bernardino held Covered Wagon Days. Like the Centennial Celebration, this four-day festival paid tribute to the way San Bernardino was when it was the Wild West. Horses and covered wagons traveled on the sawdust-covered streets, and some participants even lived in their wagons in a camp for the four days and nights.

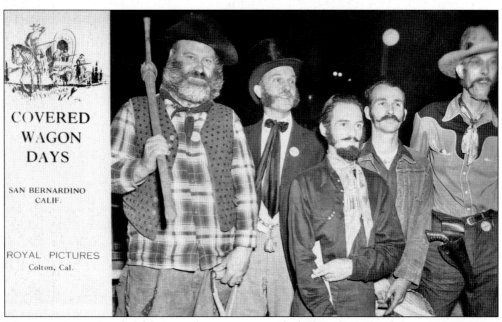

Men started growing facial hair weeks or even months before the start of that year's Covered Wagon Days to participate in the competitions for the best beards, mustaches, and sideburns. If men at the festival were clean-shaven, they risked a chance of being caught by the posse. If caught, the men would be called a "Smooth Puss" and risk being put in a mock jail unless a "fine" was paid.

Four

PUBLIC BUILDINGS

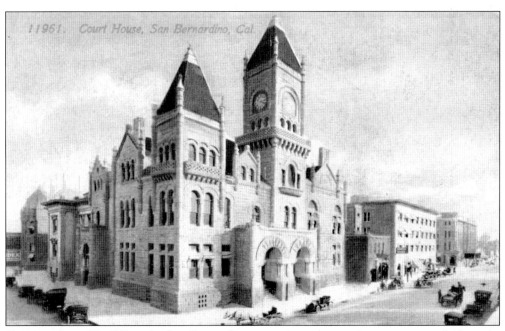

Construction of buildings in San Bernardino started as soon as the streets were laid out in 1853. The first public building was the Mormon Council House built on Grafton Street, as it was known in Mormon times. It is now called Arrowhead Avenue. The council house was used as a post office, council office, school, church, and the county courthouse from 1854 until 1858. One of the city's most beautiful buildings was the courthouse that first opened its doors in 1898.

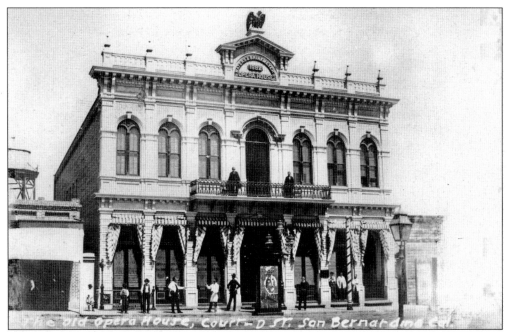

In 1882, James Waters and Herman Brinkmeyer teamed up to build the San Bernardino Opera House on D Street between Third and Fourth Streets. Built of redbrick with a gold-plated eagle on top, the opera house was said to be one of the finest theater buildings outside San Francisco. With seating for 900 people, performers included Lillie Langtry, Sarah Bernhardt, Al Jolson, and George M. Cohan.

Lillie Langtry was born in 1853 on a British island named Jersey. The "Jersey Lily," as she was called, became an American citizen in 1887 and came to San Bernardino on May 3, 1888. She performed on stage at the San Bernardino Opera House in a show called *A Wife's Peril*. She probably stayed in the four-story Stewart Hotel, the most elaborate hotel in the city.

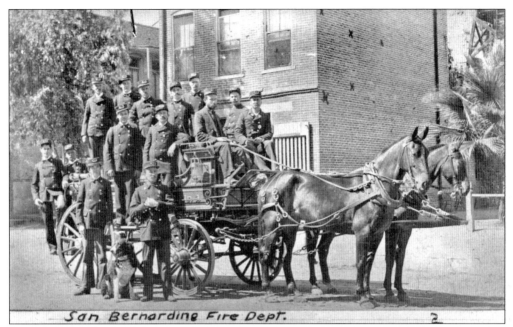

In 1890, the entire water system in San Bernardino was enhanced to achieve high pressure and large capacity in hydrants all over the city. The steam fire engine was no longer needed. Allen Iron Works built this specially designed hose wagon in San Bernardino. The wagon only carried hose, nozzles, and men. Along with the ladder truck, fire fighters had all the equipment they needed to fight most fires.

The City Pavilion was built in the center of Lugo Park (now Pioneer Park) in 1891, and was the city's gathering spot for social affairs, religious gatherings, and political rallies. The local contingent of the National Guard used the basement as an armory. In 1913, the ammunition caught fire and destroyed the entire building, despite the fact that the fire department arrived on scene two minutes after the alarm.

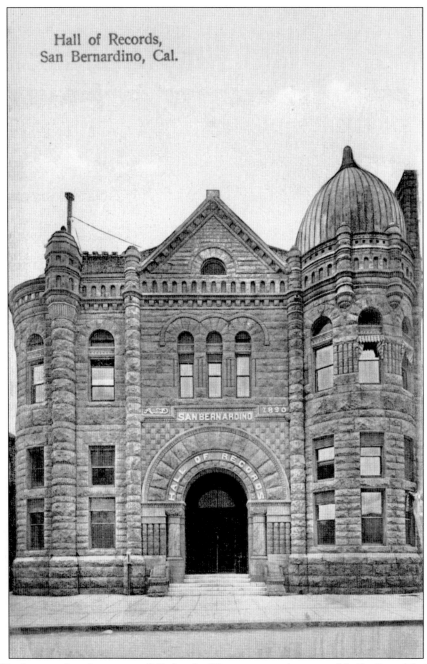

In 1887, after two bond measures failed to build a new courthouse and hall of records, county supervisors imposed a direct tax for a new hall of records. This action by the board of supervisors was a major factor in the decision for Riverside to break away from San Bernardino County in 1893 and form a separate county. The construction of the San Bernardino County Hall of Records was completed in 1891 and located on Court Street between D and E Streets, adjacent to the 1874 courthouse. This beautiful structure was made of local red mentone sandstone and Colton marble. It was said to be modern, fireproof, and earthquake proof and the best structure of its kind in the state.

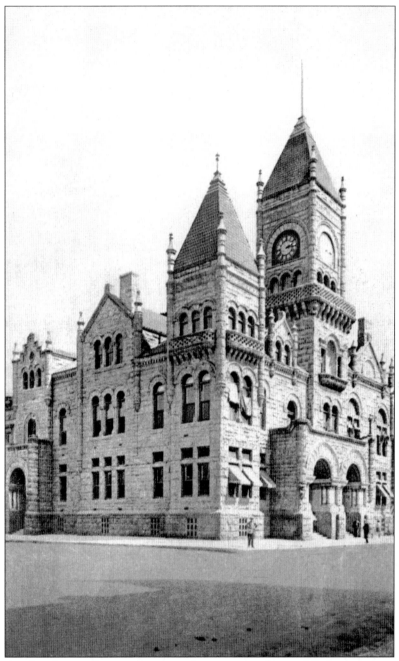

After another bond issue for construction of a new courthouse failed, supervisors imposed another direct tax. The second county courthouse was three stories tall and finished in 1898. It stood on the southeast corner of Court and E Streets, directly in front of and connected to the 1874 courthouse. Both buildings can be seen behind the Carnegie Library on page 50. Like the hall of records, the courthouse was made of local red mentone sandstone. It was trimmed with local Colton marble and sespe sandstone from Ventura County. The massive bell tower housed a Seth-Thomas clock that was wisely saved and stored for many years. Today it is displayed close to its original location (page 54).

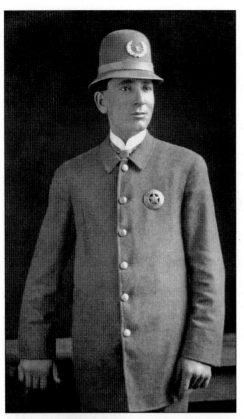

The law had been consistently enforced in San Bernardino since 1852, whether by sheriffs, marshals, or policemen. Ed Poppett was called a policeman when he started working for the city marshal in 1901. In 1905, the new city charter allowed the formation of a "Police Department," and Ed was one of the first officers. Walter Shay was the last city marshal and became the first police chief.

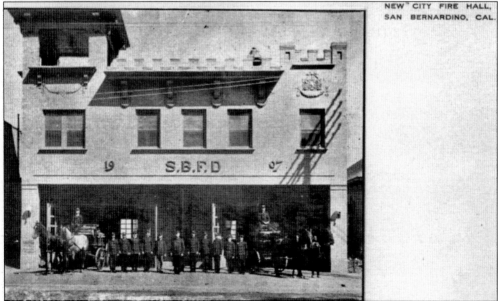

On March 25, 1907, Chief George Stephens laid the cornerstone for the new fire station on Fourth Street near D Street. The total cost of construction was $13,385. The cost of just a new fire engine today is a quarter-million dollars. In 1907, the city was so proud of their new station they sent out postcards of it.

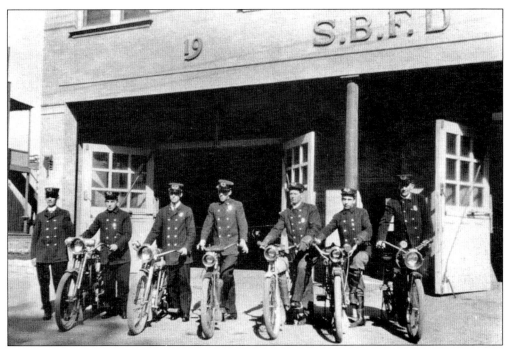

Around 1911, the San Bernardino Fire Department started using motorcycles to get to fires. Most of the firemen were volunteers at that time and used the motorcycles to get from their regular job to the fire when the bell went off in town. The tall man on the right is the fire chief William Starke, and he even had "Chief SBFD" painted on the gas tank.

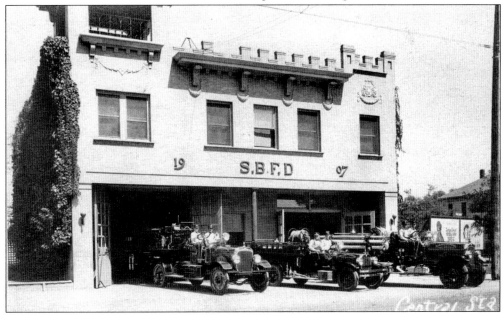

In 1929, the fire department bought its first aerial ladder truck, shown on the far left. The truck had an 85-foot ladder that could be raised as fast as modern aerial ladders today and was a necessary component in rescue and extinguishment. The two fire engines pictured were purchased in 1926. The Seagrave Company manufactured all three pieces.

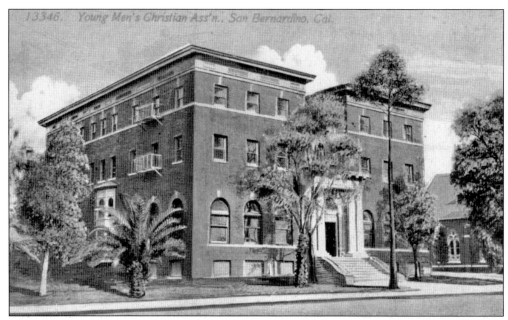

The YMCA was originally started in San Bernardino in 1885 at Garner Hall on D Street. It became a popular place for young men looking for inexpensive lodging. When a larger facility was needed, this new Y was built on the northwest corner of Fifth and F Streets. Rooms were rented by the week or month, and two dormitories were reserved for overnight guests.

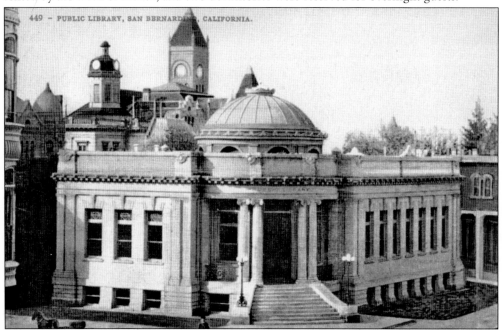

Philanthropist Andrew Carnegie made a $20,000 grant to San Bernardino for construction of this classical revival–style library that opened in August 1904. In 1920, a city bond that matched Carnegie's contribution provided for an addition. In 1957, the building was declared unsafe and demolished in 1958. A new library was built in 1960. Both the 1874 and 1898 courthouses are visible behind the library.

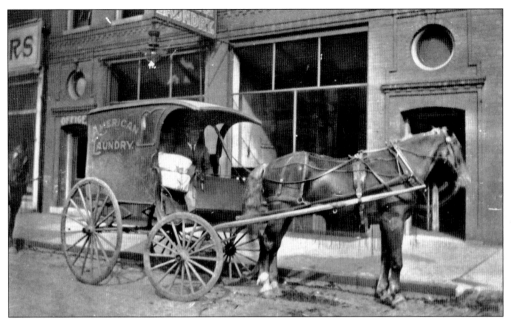

Many laundries like this have existed in the city's past. Like this one, some even offered pickup and delivery. In an 1887 directory of San Bernardino, six laundries were listed within the city. That's quite a few considering the population was less than 4,000. Of the six laundries listed, four were Chinese owned. They were located on Third Street east of Arrowhead Avenue, which was then considered the outskirts of the city.

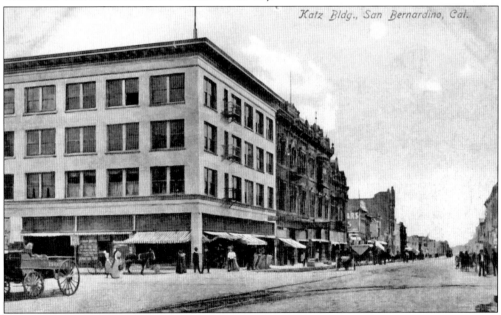

Marcus Katz was an amazing Jewish pioneer. He was a merchant, county treasurer, notary public, and Wells-Fargo agent, all before 1860. He was an original member of the Pioneer Society and established the Jewish cemetery. This four-story Katz Building was built in the 1890s. Sadly, before completion, 86-year-old Katz became ill and died. His son Maurice took over. The building wasn't demolished until 1969.

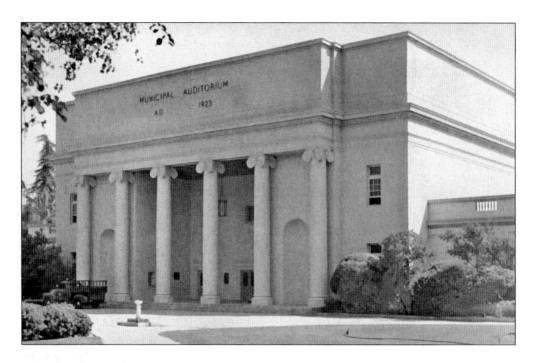

As a replacement for the old City Pavilion (page 45), the Municipal Auditorium was built in Pioneer Park in 1923 as a memorial to World War I soldiers and was the first building west of New York to use acoustic tile. It hosted the big bands and rock bands until 1966. When it didn't meet building and safety codes in the early 1980s, it was demolished. The Soldiers and Sailors Monument was built in 1916 to honor veterans of the American Revolution, the Mexican-American War, the Civil War, and the Spanish-American War. Before the new Feldheym Central Library could be built on the site of the old Municipal Auditorium, this monument had to be moved closer to the corner of Sixth and E Streets.

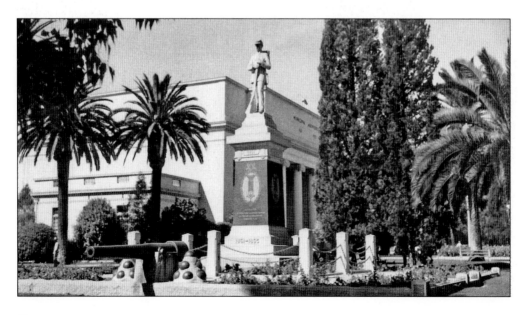

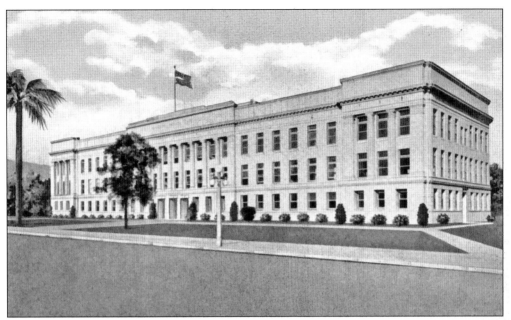

The third and current county courthouse was built on Arrowhead Avenue at Court Street in 1926 on the site of the 1852 Fort San Bernardino. In 1839, the home of Jose Del Carmen Lugo, one of the grantees of the Rancho San Bernardino, was located on the site. The second courthouse, built with sandstone and other masonry, was severely damaged in the 6.3-magnitude earthquake of 1923.

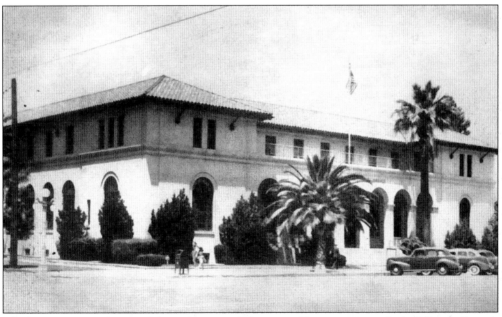

The booming population of the 1920s caused the post office to outgrow its building at Fourth and D Streets. A new one was built in 1931 at the corner of Fifth and D Streets. This ornate, two-story building with its interior of marble and oak is also on the National Register of Historic Places and continues to be used today

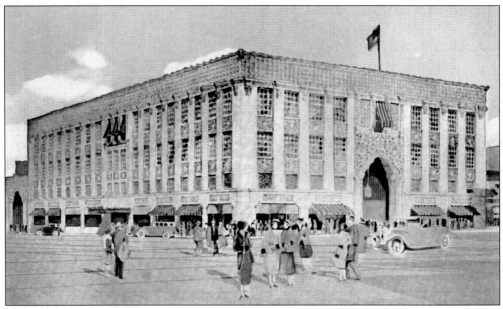

The three Harris brothers came to San Bernardino in 1905 and opened a dry goods store on Third Street knowing the city was experiencing significant growth because of the railroad. After a year, they outgrew the first store and moved across the street. In 1927, they constructed this new building at Third and E Street that became the cornerstone of downtown businesses for years. The vacant building is still there.

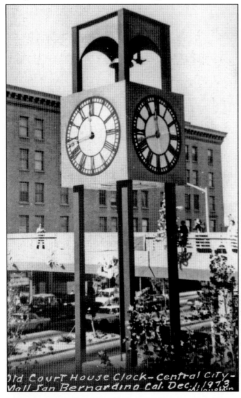

The second courthouse, dating from 1898 (page 47), was demolished in 1928. The large clock from the tower, with a face on all four sides, was put into storage. More than 40 years later, a group of people spearheaded by newspaper columnist Earl Buie restored the clock to running order. In 1972, it was placed in this new tower, close to its original location, and is there today.

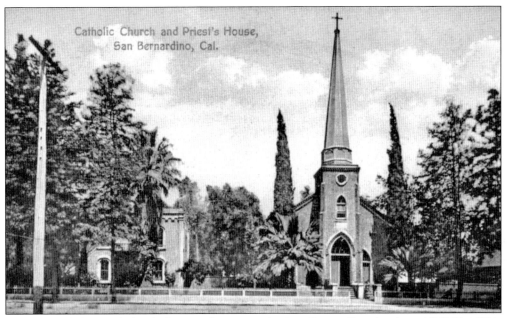

Members of the Catholic faith started meeting in San Bernardino in the mid-1850s. This church, St. Bernadine of Siena, was built in 1870 on the corner of Fifth and F Streets. By 1891, the parish included San Bernardino, which had only about 100 Catholic families at the time, and a large part of San Diego County. At that time, Riverside had not split to form its own county.

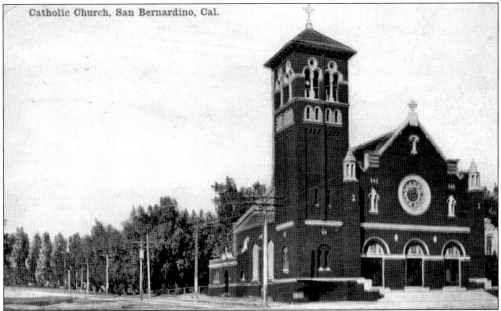

During the Centennial Celebration in 1910, the cornerstone of this new church was laid adjacent to the first one. Moorish architecture was used for this redbrick structure. In 1923, there was a magnitude-6.3 earthquake along the San Jacinto Fault centered seven miles south of the city. The tall bell tower was damaged so badly it had to be demolished. The rest of the church still remains today.

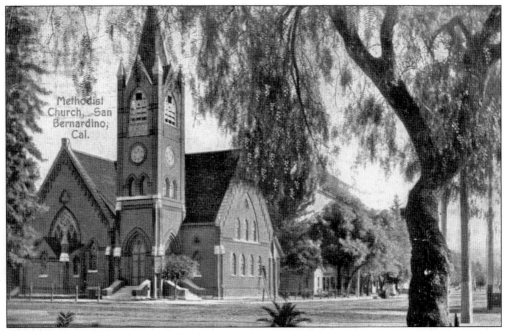

St. Paul's Methodist Church of San Bernardino was originally built in 1866. In 1887, a lot was purchased on the corner of Sixth and E Streets. This beautiful brick structure was built at a cost of $30,000. In 1955, the cornerstone for the new church was laid, and a new church was built on the corner of Eighth Street and Arrowhead Avenue, where it stands today.

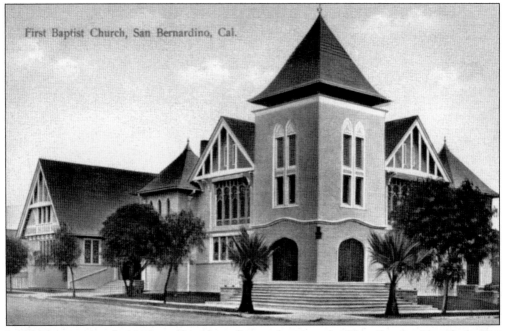

In 1866, a group of citizens gathered to discuss forming the First Baptist Church in San Bernardino. Among the group was Dr. Ben Barton. The group was too small to build a church until 1881, when the first building was built on Third Street between F and G Streets. This later church was dedicated in October 1905 and was on the corner of Fourth and D Streets.

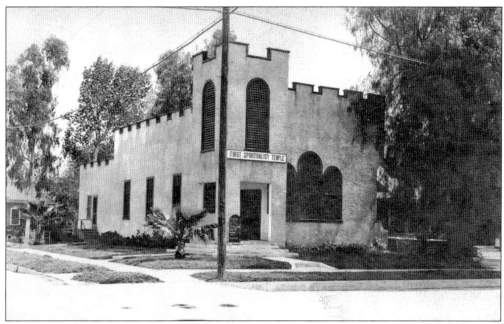

Members of the Spiritualist Church have the belief that the spirits of the dead, living on a higher plane of existence, can be contacted by mediums for guidance in both worldly and spiritual matters. Several San Bernardino pioneers were spiritualists. In 1897, John Brown wrote a book about his mediumistic experiences titled *Medium of the Rockies*. This church was located at Sixth Street and Arrowhead Avenue.

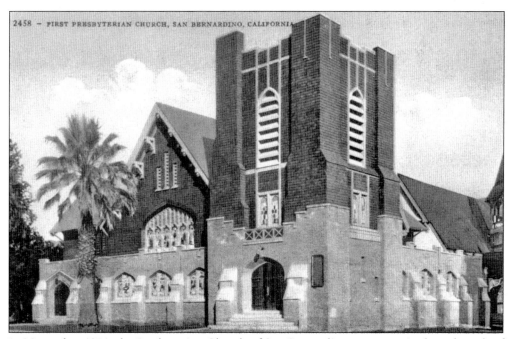

In November 1874, the Presbyterian Church of San Bernardino was organized as a branch of the Colton church. A San Bernardino church was finally built at Church and E Streets in 1885. This church was built in 1910 and was located at 555 E Street.

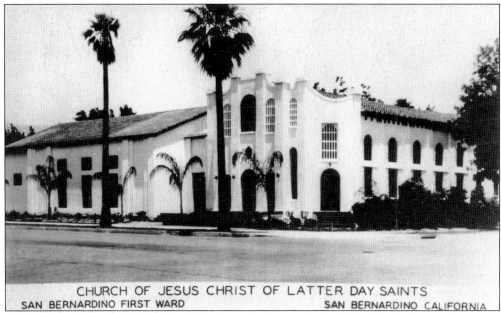

CHURCH OF JESUS CHRIST OF LATTER DAY SAINTS
SAN BERNARDINO FIRST WARD SAN BERNARDINO CALIFORNIA

The Church of Jesus Christ of Latter Day Saints was organized in San Bernardino in 1864. Their creed stated, "we believe that the doctrines of plurality and a community of wives are heresies and are opposed to the law of God." A large membership soon developed. Their first building was built on D Street between Third and Fourth Streets. In 1887, they built this church at Fifth and G Streets.

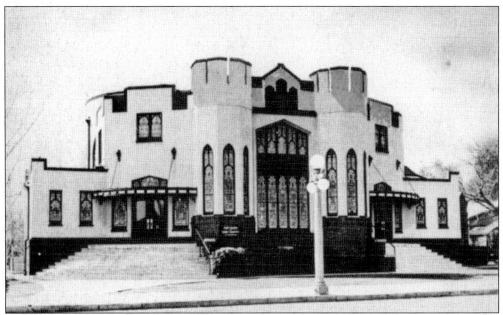

A church of Christian Science was organized in San Bernardino in December 1893. In 1904, property was bought on E Street between Seventh and Eighth Streets. In 1913, land adjacent to it was bought. Early in 1916, ground was broken for this First Church of Christian Science; because of World War I, work slowed but was completed in May 1916.

In 1923, a First Assembly of God Church was organized in San Bernardino. The first church was built at Fourth Street and Sierra Way. This sanctuary and Sunday school was built in 1951 and is located at 863 Mountain View Avenue.

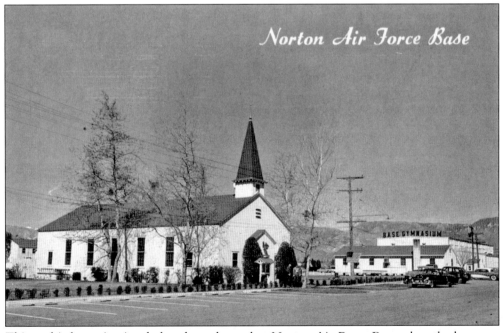

This multi-denominational chapel was located at Norton Air Force Base when the base was in full operation. This photograph was taken in the late 1950s. The chapel was replaced in the 1980s. The base was closed in 1995.

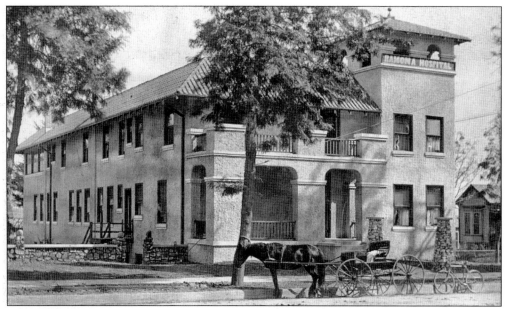

The doctor's buggy stands ready in front of the Ramona Hospital, built in 1908 and located on the corner of Fourth Street and Arrowhead Avenue. With 50 beds, it was said to be a modern, high-class surgical hospital and was a big improvement over the first hospital in San Bernardino, established in 1877 and located at Second and D Streets. Actor Gene Hackman was born at the Ramona Hospital in 1930.

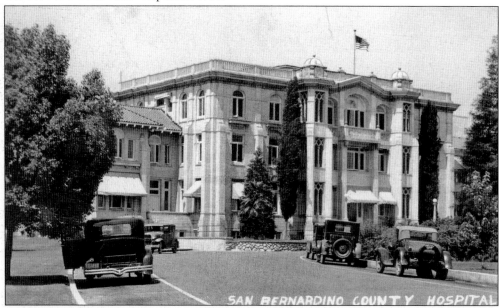

San Bernardino County opened this three-story, Gothic-style General Hospital in February 1918. Located in what was the northeast part of the city, the new hospital had 194 beds. The surrounding acreage was used for farming and dairying, supplying the hospital with fresh vegetables, milk, and cheese. The "County Farm," as the area around the hospital was known, even won blue ribbons at the Southern California Fair in Riverside with its prized Holstein cows.

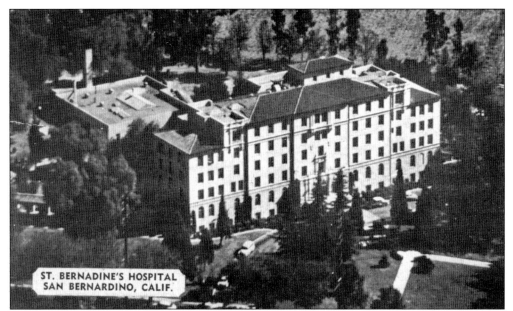

In December 1929, local doctors and businessmen concerned about the lack of adequate hospital services formed a trust agreement. With their personal resources, 17 acres were purchased and $100,000 was raised. The Sisters of Charity of the Incarnate World from Houston, Texas, contributed the $550,000 needed to build this six-story structure. Opening in 1931, St. Bernadine's Hospital was considered a first-class hospital and had 125 rooms and five surgical suites.

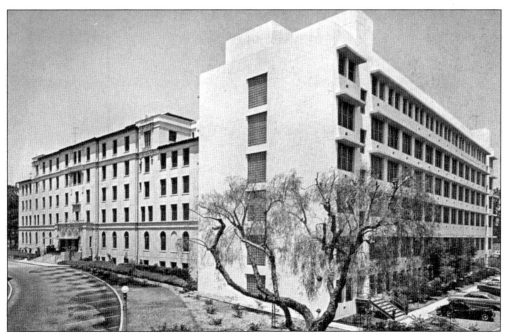

In the early 1950s, it became evident that St. Bernadine's needed more beds. Community leaders again stepped up, and in 1960, the south wing was added at a cost of $3 million. By the early 1980s, the hospital was serving over 18,000 patients a year with 1,200 employees and 25 doctors. The hospital today has expanded several more times.

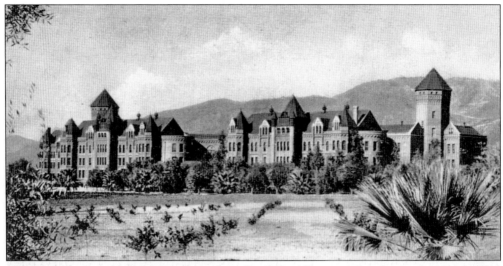

California governor Robert Waterman, from San Bernardino, appointed a commission in 1890 to examine locations for a new state mental hospital. With the first building completed in 1893, the Southern California Asylum for the Insane was opened. By 1903, the administration building and other wings were completed. In 1904, there were 800 inmates housed in nine wards. Employees were required to live on the grounds.

The name was shortened in 1897 to the Southern California State Hospital. The hospital was almost self-sufficient, with 670 acres of farming and dairy land. Along with a chicken ranch, dairy, piggery, vegetable garden, and fruit orchard, it also had a furniture shop, shoe shop, tailor shop, sewing room, and laundry. In 1927, the hospital was renamed to Patton State Hospital after an early member of the board of trustees.

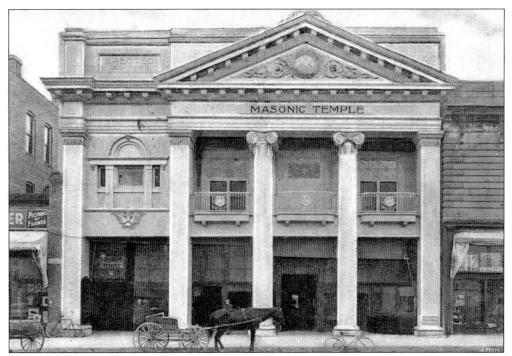

The first meeting of the Masonic Order in San Bernardino occurred in 1865 in an adobe building. In 1866, Phoenix was suggested to be the name of the new lodge. The first lodge was on D Street between Third and Fifth Streets. The lodge shown was dedicated in June 1904 and was on E Street between Court and Fourth Streets.

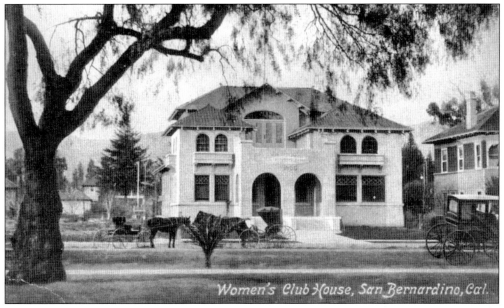

The Women's Club was organized in San Bernardino in 1892 with 10 women. Anna Garner formally organized the group in 1899. This clubhouse on Sixth Street between E and F Streets was built in 1906. The building has celebrated its 100th anniversary and is now the Assistance League of San Bernardino, which houses the Children's Dental Clinic.

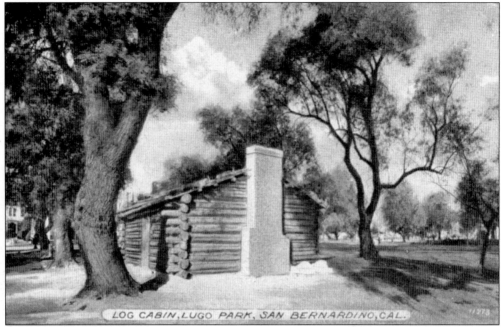

The San Bernardino Society of California Pioneers was founded in 1888. In 1908, the pioneers, between 70 and 80 years old, braved the snow-covered mountains to cut logs for this cabin to be used at the Festival of the Arrowhead Street Fair. It was moved to Lugo Park in 1911 and became their new headquarters. The park was soon renamed Pioneer Park. The cabin was destroyed by fire in 1973.

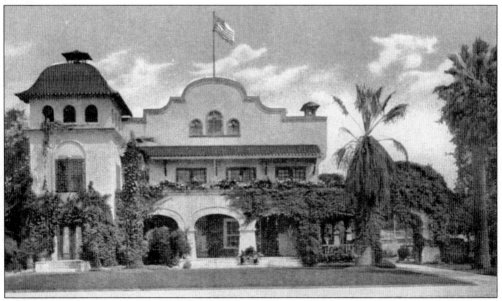

The Elks lodge was founded in February 1903 when Elks from other communities and an initiatory team from the Pasadena Lodge came to San Bernardino to perform the ritual ceremony. Their first meeting was held in the Masonic Temple. In November 1908, the first meeting in this new lodge was held. It was on the southwest corner of Fourth and E Streets.

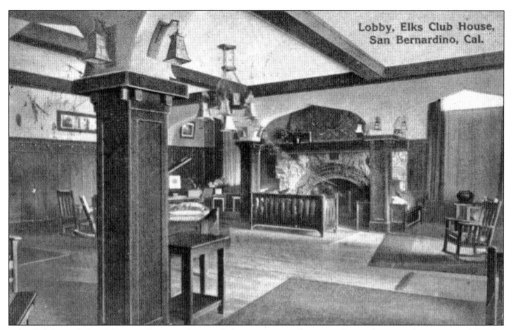

The lobby of the Elks Lodge, in beautiful mission style, was done during the arts and crafts movement in California. It was known to be the warmest and friendliest of all Elks lodges and was once known as the "Host of the Coast." This great building lasted 58 years, but sadly it was demolished in 1961.

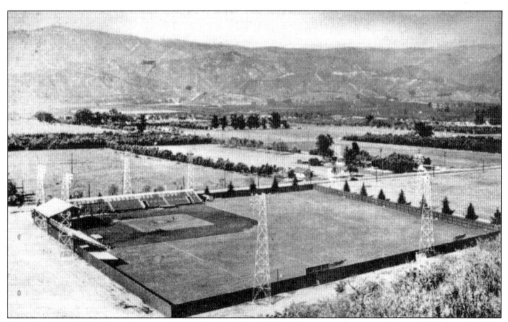

The Perris Hill Ballpark was originally built in 1934. Almost every year from 1935 until 1952, except during World War II, it was the spring training location for the Pittsburgh Pirates. In 1938, Babe Ruth came here when he was signed as a coach for the Brooklyn Dodgers. This structure was replaced for the Class A San Bernardino Spirit in 1987 and used until 1996 by players such as Ken Griffey Jr.

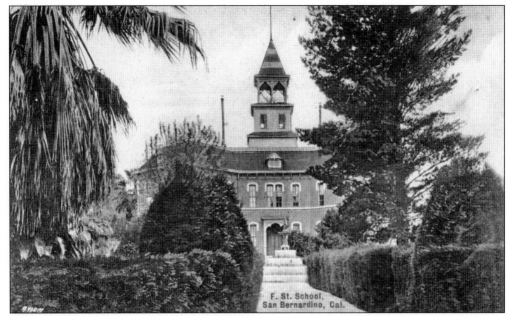

The two-story, brick F Street School was built in 1884. It was, of course, on F Street between Fifth and Sixth Streets and patterned after an award-winning design at the Centennial Exhibition in 1876 in Philadelphia. There were only eight rooms arranged in the shape of a cross, four upstairs and four downstairs. Like many buildings in the city, it was damaged by the earthquake of 1923 and closed.

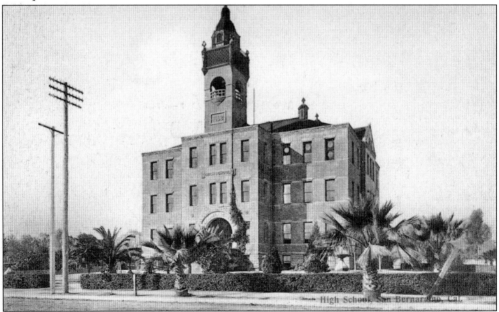

In 1891, San Bernardino High School welcomed its first students. Built on E Street between Seventh and Eighth Streets, the school was state-of-the-art at the time, with an electric bell system and speaking tubes from the principal's office to every room. From 1891 to 1982, there were only 19 principals. In 1893, the first graduating class received their diplomas at Waters and Brinkmeyer's San Bernardino Opera House.

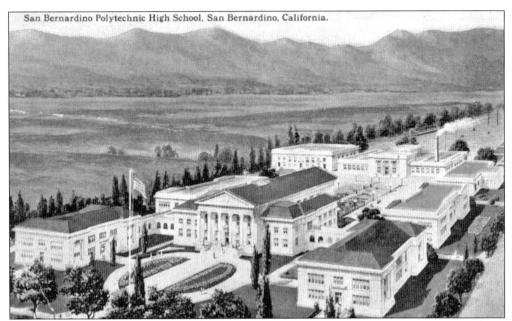

San Bernardino Polytechnic High School, San Bernardino, California.

With school enrollment over 400, a new, larger school had to be built. A large furor was caused in the city when the corner of Eighteenth and E Streets was chosen as the new school location. It was very far north of town and considered out in the country. The streetcar didn't even run that far. In 1915, the first buildings of this new San Bernardino Polytechnic High School (today San Bernardino High School) opened.

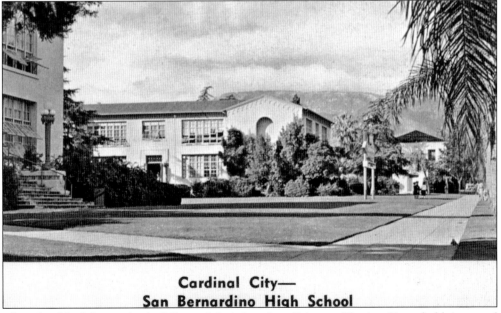

Cardinal City— San Bernardino High School

The school had five major buildings: Administration, Science, Classics, Household Arts, and Manual Arts. By 1916, there were 650 students. The cardinal was chosen as the school mascot, along with the colors red, black, and white. Starting in 1968, many of the old buildings were replaced with newer ones. The school is still on the same grounds. There are now five standard high schools in San Bernardino.

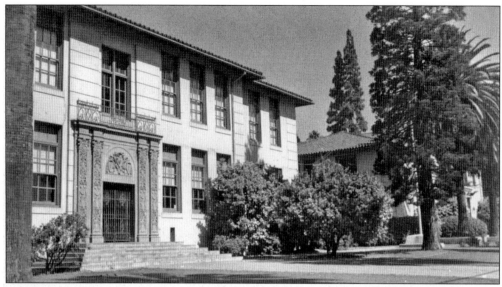

The first county superintendent of schools was David Sturges. In 1883, he founded and directed the predecessor of a high school, Sturges Academy. In the 1887 San Bernardino City and County Directory, he offered education in "general culture and citizenship," or college preparatory courses. In 1924, a new junior high school was needed for the students using the old high school, which was damaged in the 1923 earthquake. The new junior high school was named for Sturges.

In the early 1980s, city officials decided to save Sturges Auditorium from the wrecking ball. It is now a beautiful, preserved theater and home to the Sturges Family Playhouse and the Canto Bello Master Chorale. The 743-seat theater hosts numerous theatrical performances. It is also the home to the San Bernardino Art Association, which houses many works by local artists, both for viewing and for sale.

On March 26, 1926, the San Bernardino Valley Union Junior College District became the first such district organized in California. In the fall of 1927, "Valley College," as it was called, opened with two buildings completed. There were 17 instructors for the 300 students enrolled for the 54 courses offered. In February 2005, Pres. Bill Clinton spoke to a standing-room-only crowd about educational issues.

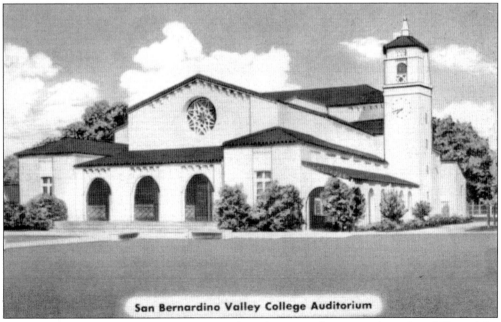

San Bernardino Valley College Auditorium

During the 1995–1996 academic year, trenching began to determine the vulnerability of the campus to future seismic activity. The results of the study revealed that 7 of the 15 buildings on campus straddled or were near the San Jacinto earthquake fault and would eventually have to be demolished. Almost all of the original buildings except for this auditorium have been replaced.

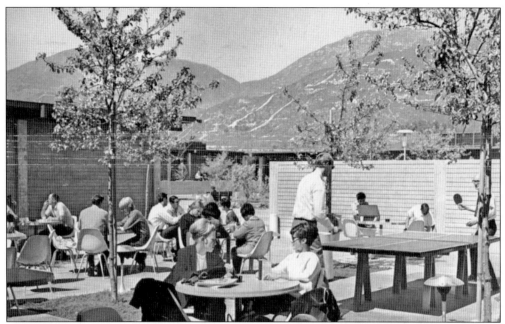

In 1965, California State College, San Bernardino was founded, serving an area encompassing more than 27,000 square miles—a territory larger than any of the 10 smallest states in America. Now a university, it is located at the foot of the San Bernardino Mountains. This early image shows the enclosed patio in the front of the Cafeteria Building.

California State University is much larger now than this vintage postcard indicates. It has five academic colleges offering more than 70 degree and certificates. Many programs have earned specialized national accreditation, including business, which was the first in the Inland Empire to gain national accreditation at both the graduate and undergraduate levels. Enrollment annually tops 16,000 and is on pace to reach more than 20,000 by 2010.

Five

Plentiful Water for Parks and Homes

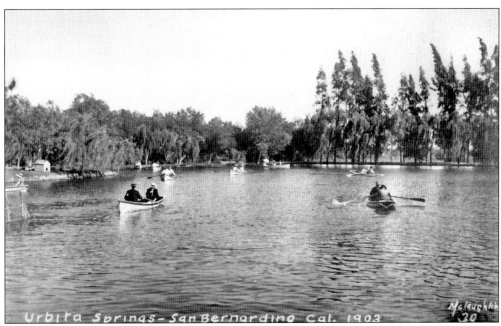

Throughout the area's long history, water has played a large part. Water was what attracted the Native Americans to the area up to 12,000 years ago. When the Mormons and others arrived, they were overjoyed with the abundance of water and vegetation. The location of the city was no accident. The center of town was placed near the confluence of Warm Creek and Town Creek. Water was the reason for the location of many of the city parks, such as Urbita Springs, shown.

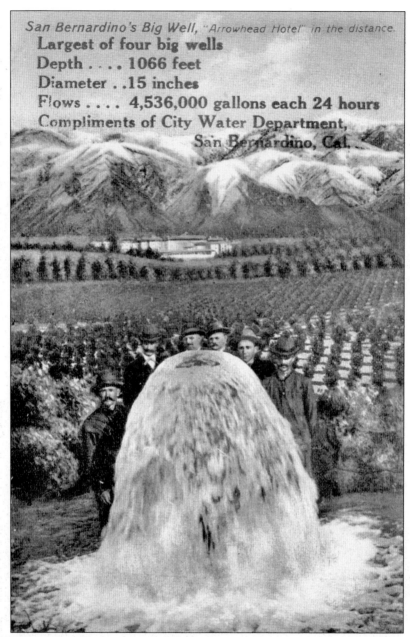

San Bernardino had an abundant water supply with, many creeks and artesian wells. A property owner could usually drill a well with a 3-inch pipe that had sufficient pressure for fire protection in a two- or three-story building. After the population boom induced by the railroads in 1886–1888, a better water system was needed to protect three- and four-story structures, such as the Southern Hotel and Stewart Hotel. In 1890, $160,000 was spent on a new water system. The original photograph used for this card shows almost nothing in the background. There are now several versions of postcards that have a variety of backgrounds. This one shows the whole valley with the orange groves and the Arrowhead on the mountain. Issued by the City Water Department, this card shows off part of the plentiful water supply with all the statistics of this large artesian well that had a constant flow of over 4.5 million gallons in a 24-hour period.

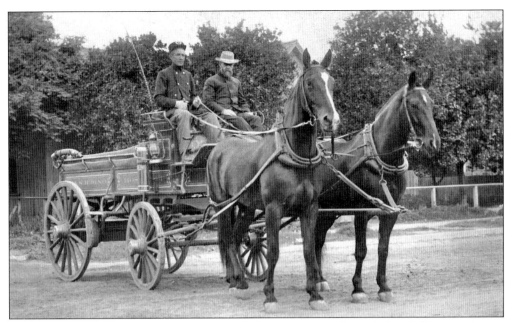

Prior to 1890, the city water system for firefighting purposes depended mainly upon cisterns and an open flow of water. Pressure was attained with the use of a steam pumper. In 1890, the water system was upgraded, and the steam pumper was replaced with this wagon that only carried a hose and nozzles. This hose wagon is today owned by the Historical and Pioneer Society and has been in six Rose Parades.

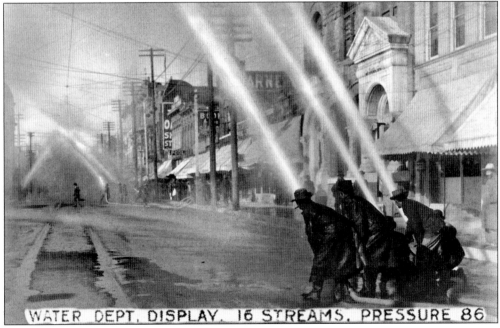

The City Water Department put out this postcard book in the early 1900s. Among city views, it shows off the $160,000 spent to upgrade to a high-pressure, gravity-fed system using steel pipe and fire hydrants placed strategically throughout the downtown. This view on Third Street shows firemen putting out 16 streams.

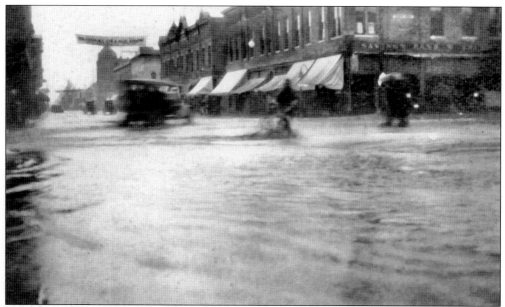

Unfortunately, water is not all good. The city had many floods in its early history. This is downtown San Bernardino in February 1914. The banner going across the street is advertising the third National Orange Show going on at the time. An urban legend exists that the Orange Show is cursed with rain almost every year during the event because it was once held on old Native American burial grounds.

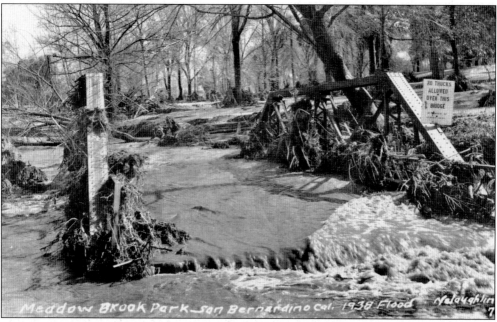

The flood of March 1938 was the most destructive to hit the valley because of the area's stage of development. The series of storms lasted five days, from February 27 until March 4, and was centered over the mountains. Depending on the area, rainfall measured 20–30 inches. The runoff was disastrous. In San Bernardino, close to 100 bridges were destroyed. The issue of flood control became a top priority.

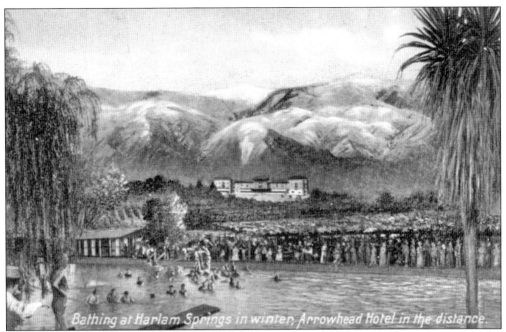

There were many hot spring resorts in the early valley. Harlem Springs, shown, was to the east of the city. The artistic license of this postcard shows the Arrowhead and the Arrowhead Hot Springs Hotel. It would have been impossible to see them from there. Harlem Springs was extremely popular after John Andreson and the Kohl brothers bought it in 1895. Transport by train was also available.

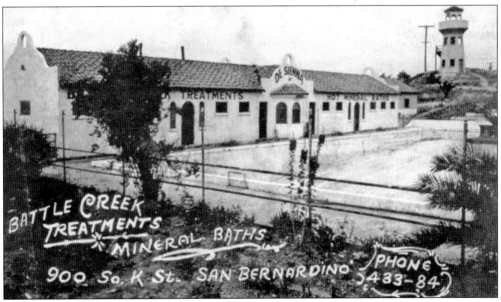

The De Siena Hot Springs was located in the southwest corner of the city. It was on the same site where reports say Padre Dumetz of the Mission San Gabriel founded a *capilla* on May 20, 1810. This being the feast day of St. Bernadine de Siena, it was named for the saint. Besides mineral baths and a warm pool, the spa had medical treatments available.

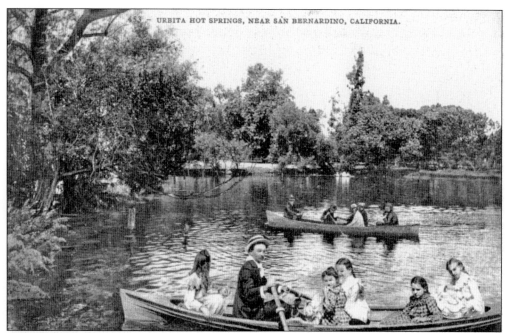

Urbita Springs was a 15-acre park located in the area now covered by the Inland Center Mall. Before settled by the white man, Native Americans used the area for the medicinal qualities of the hot water. Urbita became popular in 1901 after the Valley Traction Company bought it and ran a trolley line on E Street from downtown San Bernardino.

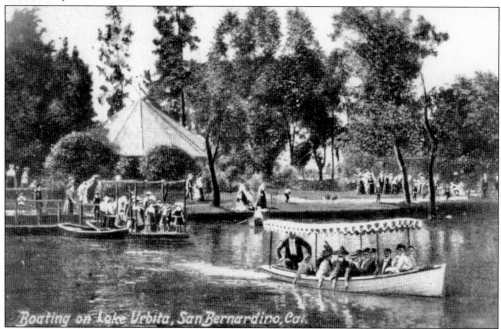

Urbita Springs, known as the playground of the citrus belt, had many things to do besides rowing a boat. Balloon ascensions were occasionally done and drew thousands of people. On July 4, 1905, 25,000 people rode the Valley Traction cars, most going to the park. Guests also could see the zoo, ride a small train, swing on a trapeze, or go to the baseball field or ballroom.

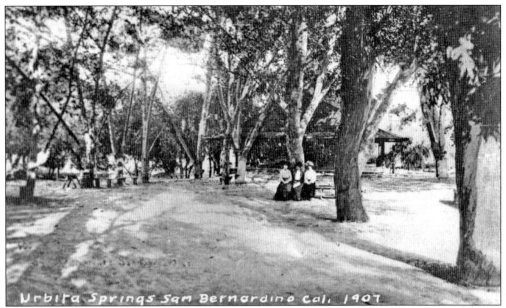

Urbita Springs was a perfect place for a picnic lunch underneath the large cottonwood and willow trees. The lake was lined with flowers and ferns that were brought there by train. The picnickers could bring their own food and drinks or buy them at the park. Geese and ducks were plentiful in and around the lake. Visitors would find freshly laid eggs on the grass and take them home.

These women don't look dressed for a picnic today, but it was probably appropriate dress in the early 20th century. Urbita routinely drew people from Los Angeles and Long Beach who traveled to the park on the now-famous Red Cars. The lake, which was expanded in 1903, was nearly a mile in circumference.

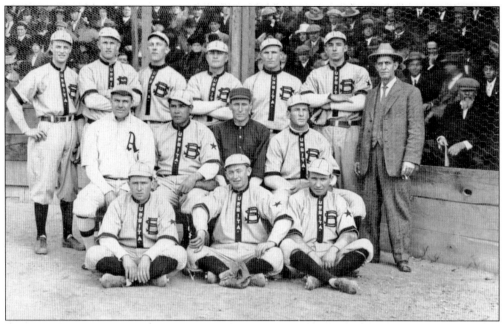

Around 1910, Urbita Springs had baseball games with major-league players as the stars on each team. In those days, major-league baseball players had to go on the road in the off-season to make extra money. This was called "barnstorming." Here a Philadelphia Athletics player poses with the rest of his team for the day. Notice the intertwined "SB" (San Bernardino) with "URBITA" running down the middle.

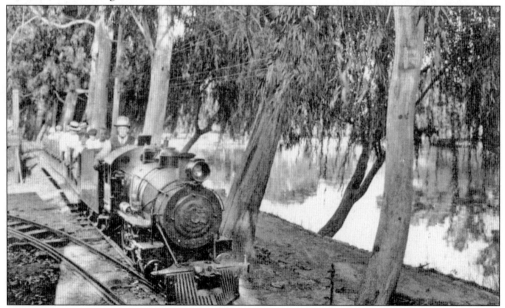

This scale-model steam locomotive is pulling about five cars past the Urbita Lake and in and around the rest of the park about 1920. Urbita was a Southern California predecessor to all the other theme parks today like Disneyland, Knott's Berry Farm, and Magic Mountain. Here one could get a "Coney Island" hotdog, cotton candy, and a cold bottle of Nehi fruit-flavored soda for about 5¢ each.

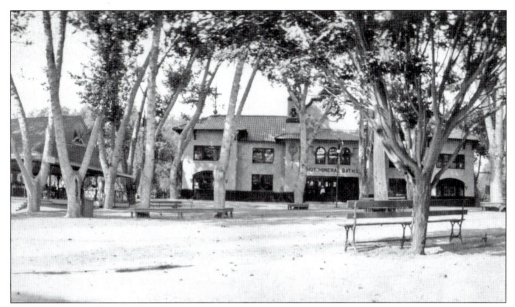

The Urbita Park Ballroom was host to many famous and not-so-famous bands throughout the years. According to historical interviews, the Urbita Ballroom was the place to get a drink during Prohibition, 1920–1933. The Pacific Electric Company operated the park from 1910 until 1924, when the automobile became dominant. In 1924, they sold it to Ernest Pickering, who renamed it Pickering Park.

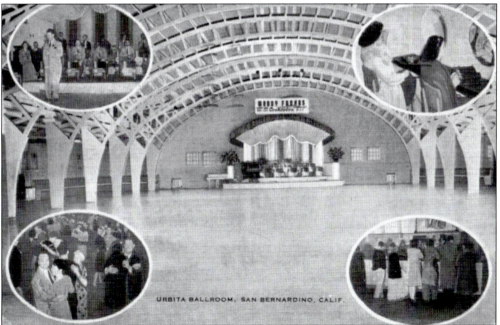

The Depression really impacted Pickering Park, as did the dropping water table and drying up of the lake. This is a rare view of the interior of Urbita Ballroom. The ballroom struggled to stay open, as any small auditorium did, with country-western dances and wedding receptions. Urbita Springs, then Pickering Park, closed for good in 1951 with the closing of the ballroom. (Courtesy of Dave Rutherfurd.)

In the 1860s, the place now called Meadowbrook Park was a swamp that was formed at the confluence of Warm Creek and Town Creek, then the south end of the young city. With its overgrown vegetation, it was an occasional rest spot for the Native Americans. Unfortunately, the area grew to be the perfect place to dump trash. In 1910, concerned citizens and the Women's Club changed all that.

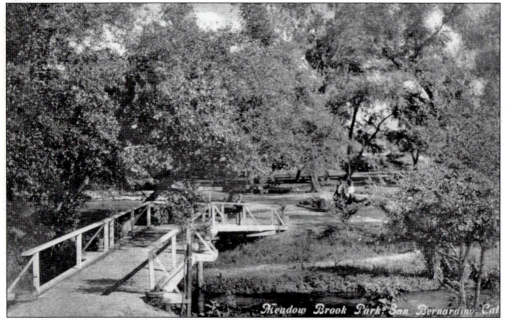

Mary Bennett Goodcell, former schoolteacher and president of the Woman's Club, organized a huge effort to change the dump into a park. The city furnished horse-drawn wagons to haul off debris for workmen and high school boys who donated a day's labor. A park was leveled off and a pond was dredged out, becoming the first city swimming pool. The park is in use today.

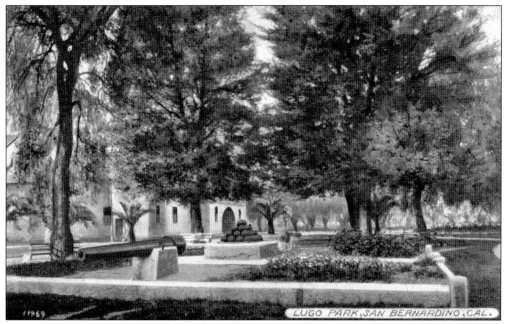

When the city was first laid out in 1853, it was only 1 mile square with 72 lots that measured a little over 1 acre each. In the center, one lot was reserved for a city park. It later became Lugo Park, named after the family Rancho San Bernardino was bought from. The City Pavilion (page 45) was located there. This armory replaced the one burned in the pavilion fire.

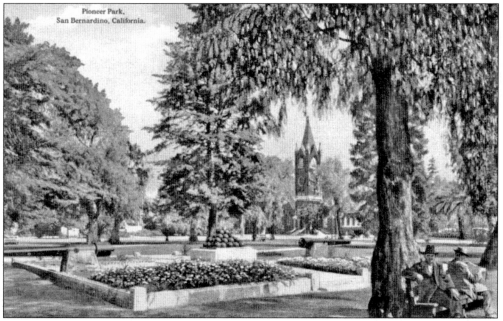

On July 2, 1915, Lugo Park became Pioneer Park after an appeal by a delegation of pioneers was granted by the city council. The Pioneer Log Cabin (page 64) had been erected in the park and dedicated in 1912. The Methodist church (page 56) is across the street. Today Pioneer Park is the home for the city's Feldheym Central Library and the California Room, housing local history information.

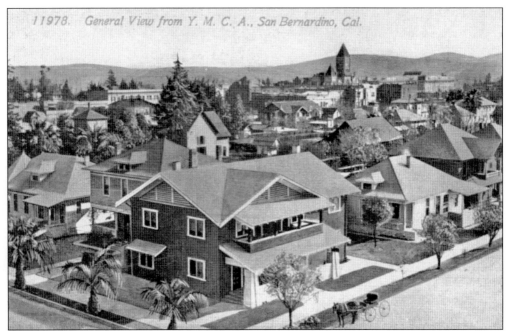

This view from the old YMCA (page 50) at Fifth and F Streets is looking southeast. With the 1898 courthouse and Post Office Block in the background, it shows the close proximity of the neighborhoods to the growing city. It was this rapid growth in the early 20th century that caused the demise of so many of the city's fine homes to builders needing the land for commerce and industry.

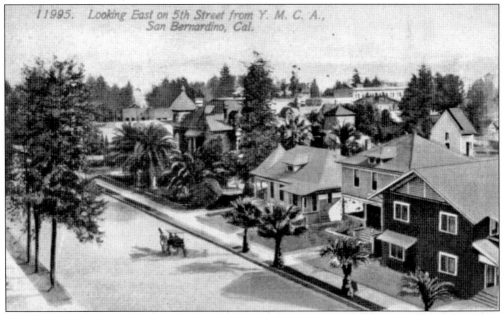

This view from the same vantage point is looking more to the east. This card was mailed in 1917, just before the United States entered World War I. The prosperity of pre–World War I can be seen here in the large homes and tree-lined streets. The Post Office Block (page 15) is the only large building that can be seen in the downtown area.

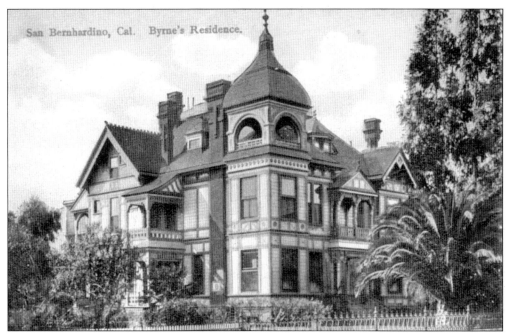

Pioneer Matthew Byrne came to San Francisco, California, in 1852 and tried his hand at mining but quickly saw that being in the mercantile business was a better way to get rich. He came to San Bernardino in 1862 and became wealthy, owning the Byrne Block. This home was on Fifth Street between E and F Streets and was featured in the *Graphic*, a Chicago newspaper about San Bernardino, in 1892.

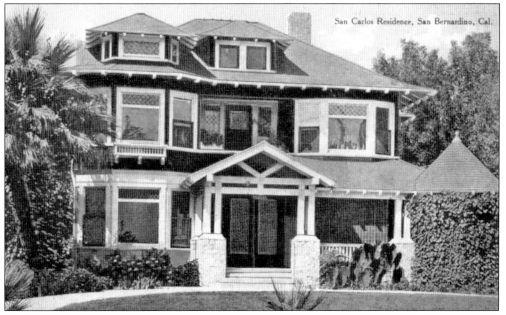

Called the San Carlos (Spanish for St. Charles) Residence, this home was on D Street between Sixth and Seventh Streets. In 1885, Charles A. Rouse married Emma Brown, daughter of famed pioneer John Brown, and lived there for many years. Considered to be an expert marksman, Rouse was elected county sheriff in 1893.

California bungalow-style homes like these were built from 1900 through the World War II era. Now because of advanced age, absentee ownership, and a lack of maintenance, many of these dwellings contribute to urban blight or are being razed for new construction.

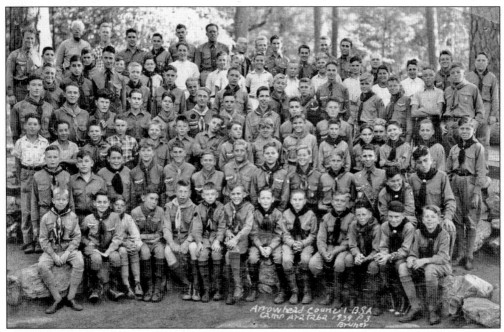

In pre–World War II, Scouting was a big part of growing up for the young residents of San Bernardino, as it was for the rest of the United States. In 1939, these teenagers of the Arrowhead Council of Boy Scouts had no idea they would soon become part of America's "Greatest Generation" and some of San Bernardino's future leaders.

Six

ARROWHEAD SPRINGS

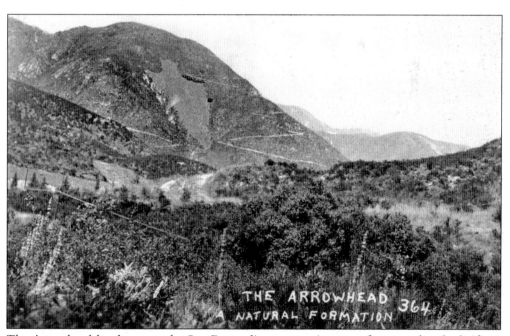

The Arrowhead has been on the San Bernardino mountain range for many hundreds if not thousands of years. It has been the symbol for many companies in the city and for the County of San Bernardino. It is a natural landmark caused by different rock and soil composition within the Arrowhead from the adjacent parts of the mountain. It is about 450 feet wide and 1,400 feet long, comprising an area of almost 8 acres.

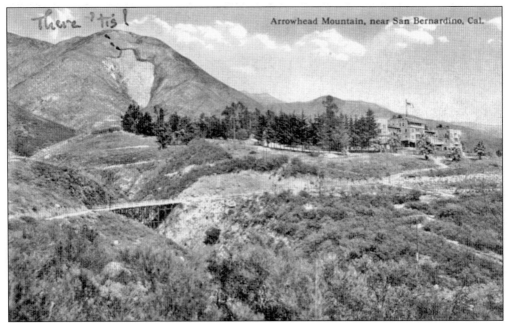

The Arrowhead is famous worldwide, and as the writer of this postcard states "There 'tis!" It is comprised of mostly weathered white quartz and gray granite that supports the growth of short, white sage. This is in sharp contrast to the dark green growth of surrounding chaparral. This distinctive symbol can be seen from miles away, but surprisingly, it goes unnoticed to some residents until it is pointed out.

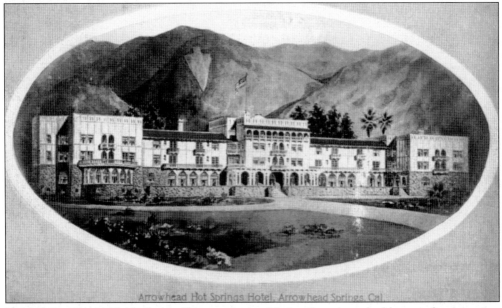

In 1864, Dr. David Noble Smith discovered what Native Americans had known for centuries. Hot springs bubbled up in the grounds beneath the Arrowhead. Dr. Smith established a treatment center for consumption, now known as tuberculosis. There have been four hotels, all called Arrowhead Springs Hotel or Arrowhead Hot Springs Hotel, located on this site. This is the third one, built in 1905.

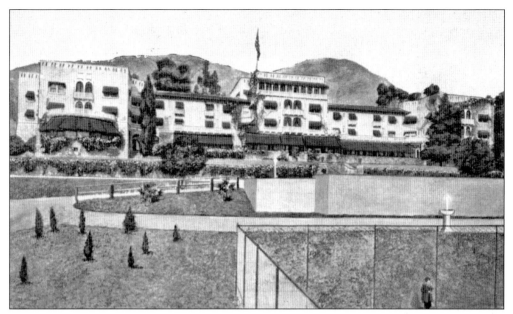

In 1930, the hotel was bought by a group of people from Hollywood, led by Joseph Schenck, and promoted as a luxury resort. During the Depression, Hollywood still had money. The hotel soon became the hangout for big-name celebrities like Humphrey Bogart, Mary Pickford, Spencer Tracy, and Loretta Young. This was the "Golden Era" of Arrowhead Springs. In 1938, a forest fire destroyed the hotel.

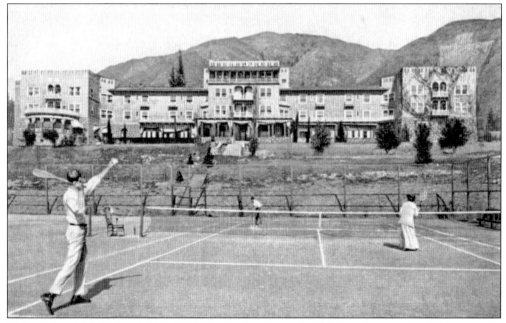

This card, which is dated May 1915, shows that it was in style to play tennis with long pants for the men and long dresses for the women. They might not have played for long if it was a summer day, typically over 90 degrees and occasionally over 100 degrees. There were two tennis courts available for the guests.

Besides playing tennis, there were many other activities. Hiking trails and horseback riding were a few of them. If one worked up a thirst at any of these activities, he could go to this "Drinking Pavilion." Remember Prohibition was from 1920 to 1933, so this pavilion was designed for people to drink the famous "Arrowhead Water" from the font located in the center. It was pure and a cool 49 degrees.

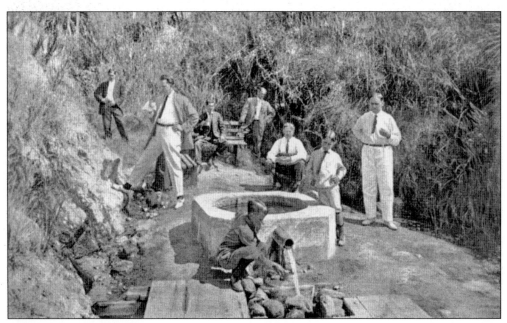

There were several different hot springs, with different temperature water on the grounds. The Penyugal Springs are said to be the hottest in the world at 202 degrees. The Granite Hot Spring, close to the hotel, is 178 degrees. The Palm Hot Spring, on the mesa above the hotel, is 180 degrees and feeds the pools, hotel, and bathhouse.

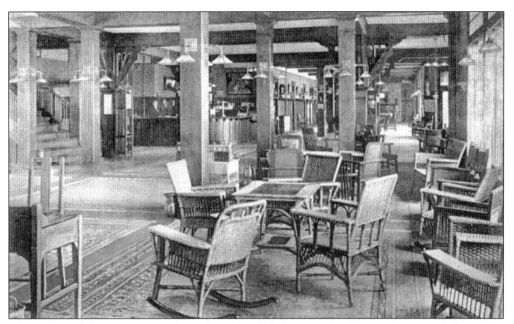

The lobby and dining room took up the entire 285-foot length of the entire ground floor. The open-beam woodwork was made of cherry, while the floor under the rugs was maple. It all goes well with the oak, mission-style furniture in the background and the wicker furniture in the foreground.

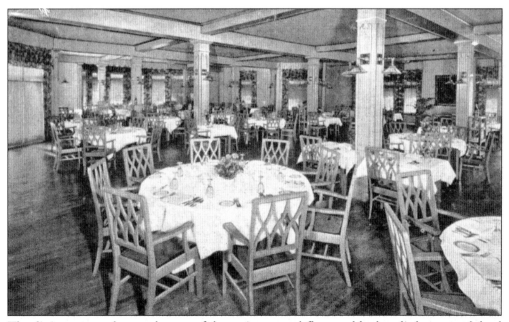

The dining room takes up the rest of the entire ground floor and looks a little more subdued than the lobby with the painted wood posts and beams and lack of rugs. The travel brochure adds that the hotel has one of the Pacific Coast's finest chefs. Windows covered the entire south wall, allowing guests to dine in a room "flooded with the glory of California's sunshine," as boasted in an 1930s Arrowhead Hot Springs Resort brochure.

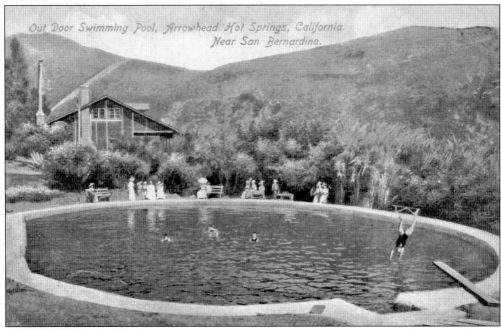

This oval-shaped swimming pool was the only pool in the third hotel, from 1905 until 1938. The pool was 60 feet wide, 90 feet long, and filled with warm mineral water. It was said to be "radio-active" and contain disodium arsenate, which both have health benefits by "increasing the appetite and improving the normal functioning of the body, imparting new tone and vigor," according to a 1930s resort brochure.

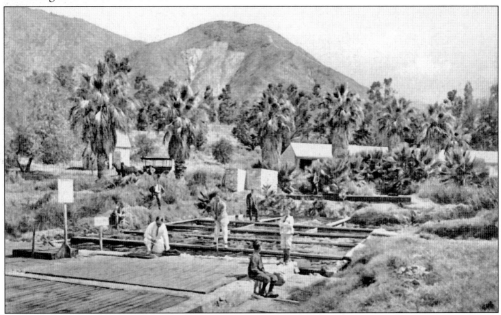

The mineralized mud bath, called the "Mud-bath Cienega," was a marsh created by numerous springs. Here also, the resort reports that the mud baths are refreshing and give immediate relief from rheumatic and similar pain because of the arsenic-impregnated mud. It was said to cure or improve almost any known disease at the time from diabetes to malaria to obesity.

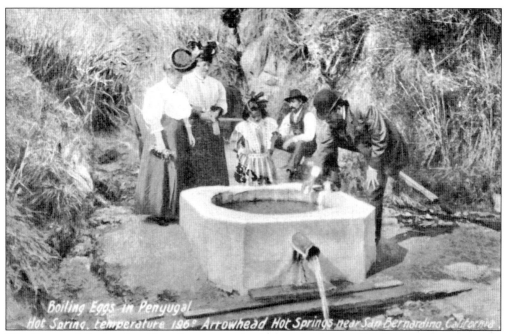

The Penyugal Spring is said to be among the hottest in the world. The water temperature gets up to anywhere from 196 to 202 degrees and is hot enough to boil eggs, as these men and women are demonstrating in their Victorian dress. This photograph was taken around 1905.

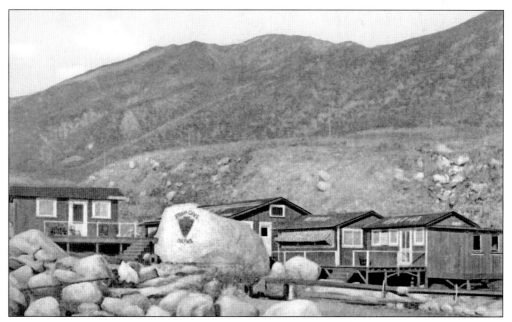

Guests could get a massage or just rest while they were in the Natural Steam Cave Bath. Even the steam was promoted to be radioactive and contain arsenic inside the new, modernly equipped building that houses the caves. The steam was said in the 1930s brochure to "open the pores of the skin giving a delightful experience of buoyancy and rejuvenation."

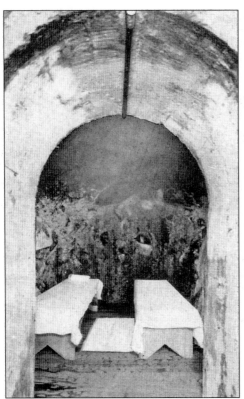

There were other steam caves located in the mountain, partially under the hotel and parking lot. They were called caves, but they were hardly that, with trained attendants and tile lining the walls and benches. These caves are still there and are still full of steam, but they have not had any upkeep in at least 40 years and are even hazardous to enter.

The cottages or bungalows were for the guests who preferred privacy and the larger living area of five rooms. There were 11 of these bungalows on the resort grounds that were close enough to permit the occupants to enjoy the recreational and social features of the hotel. Many Hollywood celebrities reportedly stayed in these bungalows. These were saved in the fire of 1938.

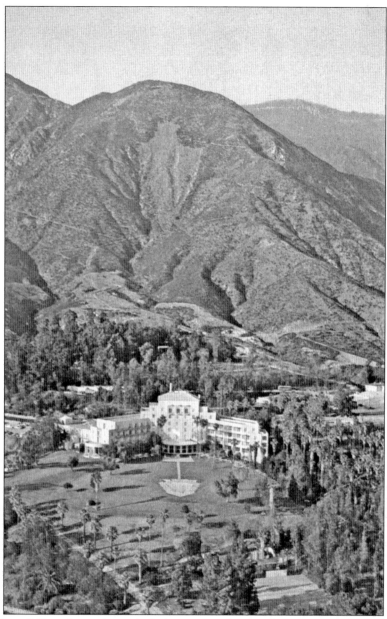

In November 1938, a Santa Ana wind–driven fire destroyed the 1905, three-story hotel. It was one of the largest fires ever in that area. At that time, there were very few homes built in the north end of the city, so firemen were able to stop it before it burned more structures. A new, $1.5-million, six-story hotel of concrete construction opened in December 1939. Paul Williams, one of America's foremost black architects, used Georgian architecture with art deco elements in his design. The grand opening in 1939, broadcast live on radio, featured stars including the Marx Brothers, Judy Garland, Al Jolson, Rudy Vallee, and Jimmy Durante. Luckily this concrete hotel has withstood several more fires over the years. In June 2002, a wildfire got so close it was hot enough inside the hotel to set off fire sprinklers, flooding the basement. The Arrowhead itself was blackened, but as has happened so many times before, it was visible again the following year.

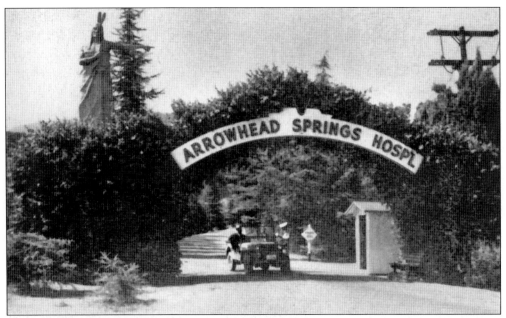

As in the First World War, soldiers were brought to Arrowhead Springs for rehabilitation in World War II, except this time the U.S. Navy took over the whole complex, making it a hospital. In 1944, it became the Arrowhead Springs Naval Convalescent Hospital. Located 65 miles from Los Angeles, it was 15 minutes away from the Santa Fe, Southern Pacific, and Union Pacific Railroads.

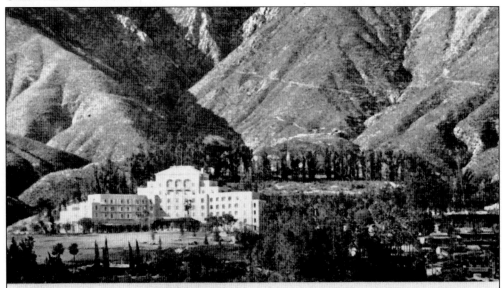

View of Hospital: Ideally located in the mountains at an elevation of 2000 feet, where the air is pure and invigorating.

This promotional card made by the navy makes a convalescent hospital look pretty attractive. About 6,000 wounded soldiers received treatment there. They probably didn't think of it as a resort, but if the caption didn't have the word "Hospital" in it, the card would look like something the travel agents handed out.

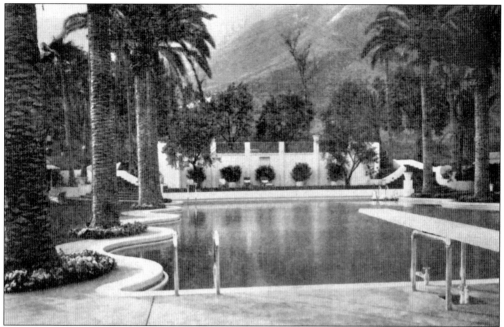

This pool had been built specially for a shot in a Hollywood movie about the same time the navy was taking over Arrowhead Springs for its convalescent hospital, Called the Cabana Pool, it was built for Olympic and film star Esther Williams in 1944. She did a swimming scene in it for a movie released in 1945 called *Thrill of a Romance* also starring Van Johnson. Two other movies had previously been shot there.

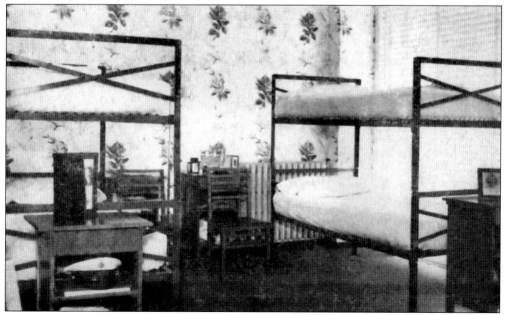

The removal of the hotel beds and addition of bunk beds in the hotel rooms was about the only way to tell it was not a resort any longer if one didn't see any patients. The hospital grounds covered the entire 1,700 acres that had been the playground for Hollywood stars only a few years before.

The cottages or bungalows were turned into the staff officers' quarters. There were only 11 of these cottages on the grounds with five rooms in each. It is unknown whether these officers had their families living with them, but there would have been plenty of room. Most of them have great views of the San Bernardino Valley below and access to all the facilities if they were needed. The cottages are still there today.

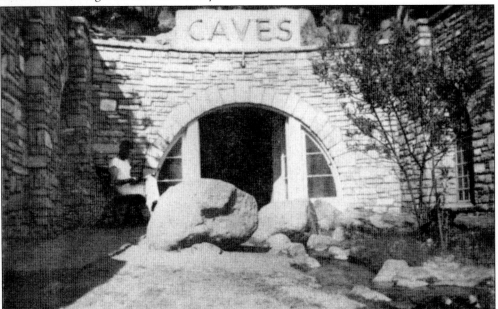

This is the entrance to the Steam Caves. To access these, there were stairs leading from the back of the parking lot next to the hotel. The stairway traversed the hillside down about 30 feet to this entrance. The caves go directly into the hillside and are deep underneath the parking lot and hotel. The caves are still there today, but dangerous to enter after being damaged by several wildfires.

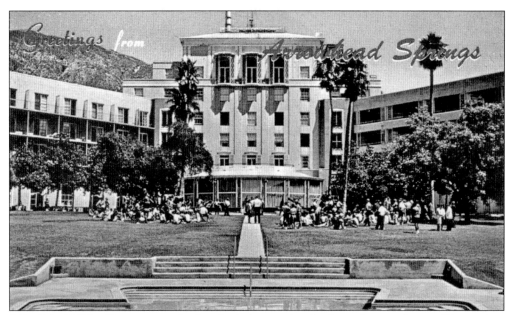

After World War II was over, the hotel tried returning back to the way it was. There were many changes of ownership, but all failed. Elizabeth Taylor married Conrad Hilton in May 1950. Owned then by Hilton Hotels, the couple spent their honeymoon on the sixth floor, probably just to get publicity for the hotel. The windows to that room can be seen here at the top in the center.

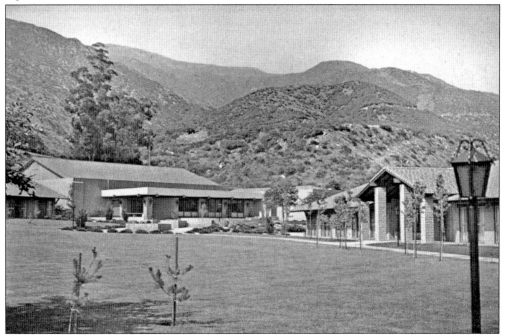

In 1962, Dr. William Bright purchased the property. He was the founder of Campus Crusade for Christ (CCC). The hotel was completely refurbished and a new dormitory and cafetorium complex was built nearby known as Arrowhead Springs Village. This view shows part of that new complex.

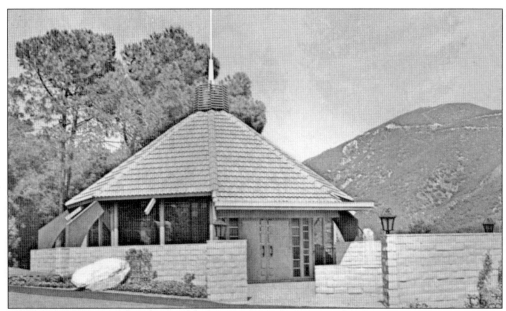

One of the other buildings added was this structure, Atkinson Memorial Chapel. Thousands of students, laymen, and pastors were trained annually at Arrowhead Springs, served by a staff of around 500. In 1991, the world headquarters of CCC was relocated to Orlando, Florida. Dr. Bright passed away in 2003. The property is currently vacant and still owned by CCC. A development company is preparing the property for sale and development.

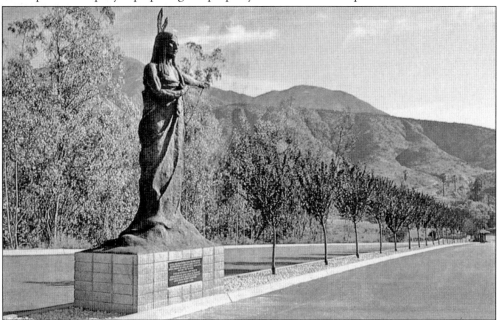

This Native American, pointing the way to the Arrowhead, originally stood at the entrance in the 1920s (page 94). In 1963, the statue was removed in a highway project. It remained neglected by the roadside until John Lowe of Campus Crusade for Christ asked the Native Sons of the Golden West (NSGW) and the Native Daughters of the Golden West to resurrect it. The project, headed by NSGW president Richard D. Thompson, was completed in 1976.

Seven

THE NATIONAL ORANGE SHOW

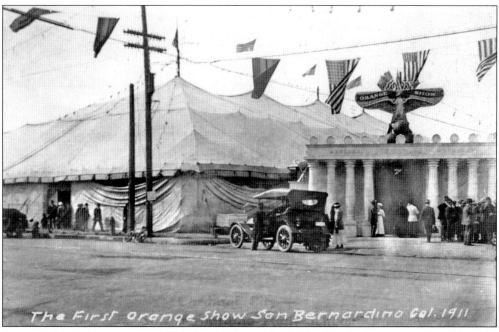

Recognizing the importance of the citrus industry in California, the San Bernardino Chamber of Commerce conceived the idea of telling their story in an exhibition full of romance and pageantry. In March 1911, the National Orange Show started in a vacant lot at Fourth and E Streets. The show included fruit stands, game booths, juggling clowns, and agricultural displays along with music from the Bell Concert Orchestra. The six-day show was a great success.

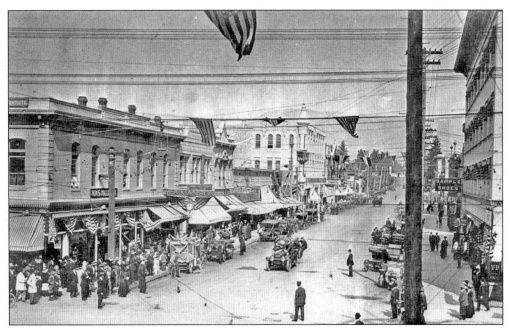

The First National Orange Show parade in 1911 included San Bernardino's first motorized fire engine. Bought in 1910, this Pope-Hartford cost $5,600 and did not have a pump. It carried 1,000 feet of hose, 30 feet of ladders, and had two chemical tanks with 200 feet of hard-rubber hose. A hotel owner in San Diego has this fire engine today in his large collection.

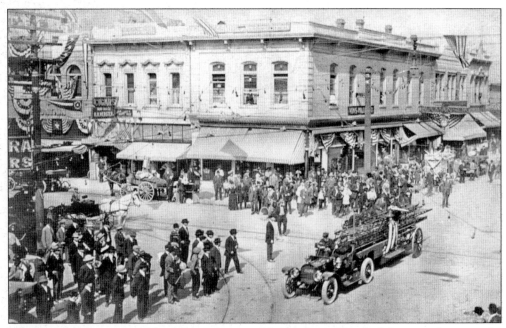

The fire department must have been happy with the Pope-Hartford because that was the company they went with when they decided to buy a tractor for the former horse-drawn ladder truck. The parade appears to have been a big hit, especially for a Monday afternoon. The festivities in the tent didn't start until 7:30 p.m.

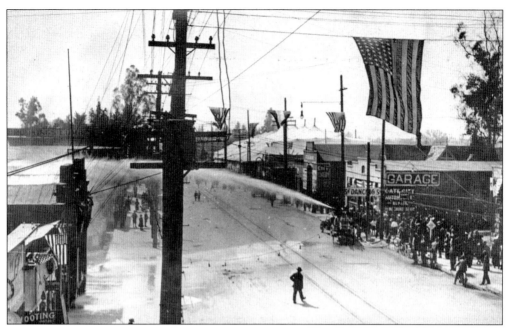

When the parade up E Street was getting close to the Orange Show, the ladder truck decided to stop between Third and Fourth Streets. They are showing the effectiveness of the city's new water system, and the truck-mounted deluge gun is connected to the hydrant with two hoses. The huge white tent of the Orange Show can be seen up the street.

In the early 1900s, "balloon rides" were popular at fairs like the First National Orange Show. Everyone needed a souvenir like this to show friends and family they were brave enough to go. The "San Berd'O" on the sign is one version of abbreviating San Bernardino that was done many times in the city's history; the most common abbreviation was "Berdoo."

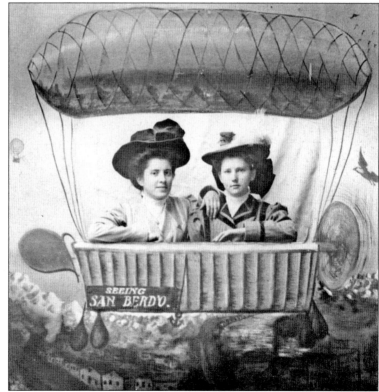

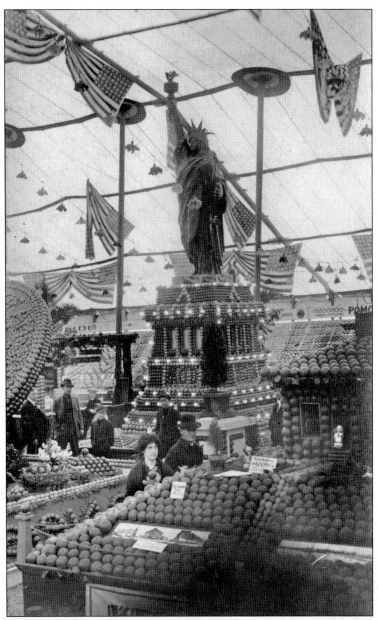

Judging by all the American flags in the streets for the parade, shown on page 100 and around this replica of the Statue of Liberty, everyone was very patriotic in the years leading up to the First World War. Looking at the people in the crowd, one can see that the statue, with its base made of oranges, must have been close to 30 feet tall. Early shows like this had many different types of entertainment as well as the huge citrus displays. There were vaudeville acts with comedians, jugglers, and animals as well as musical and dancing shows. There were concerts every day, with groups such as the 7th Regiment Band, the Santa Fe Band, the Royal Hawaiian Orchestra, and Prof. F. Crossland's Orchestra. There were children's parades along with the regular Orange Show Parade. A midway was set up with games and entertainment, like a 100-foot high dive and fireworks at night. The early shows were held in tents, as this image shows.

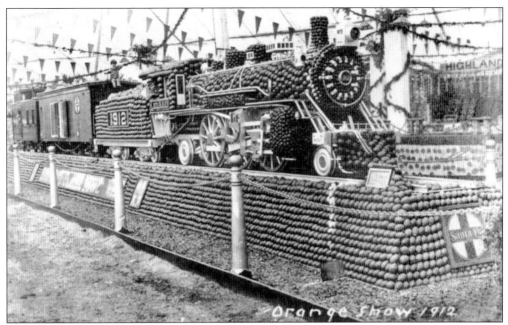

In 1912, the show greatly expanded from the first year. Citrus-growing communities from across the country built massive displays. Even the Santa Fe Railroad put together this almost-life-size replica of a steam locomotive. The National Orange Show was highly successful in promoting the superior quality of the California orange. New markets were developed throughout the United States and even in foreign countries.

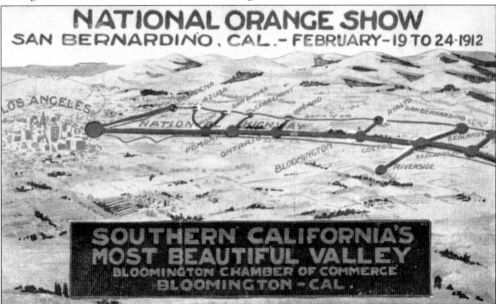

This postcard was distributed in 1912 by the community of Bloomington, one of the neighbors to the west. It is a good reference, showing all the cities between Los Angeles and San Bernardino. The main route that is highlighted is the "National Highway" or Route 66. Below it (to the south) are the tracks of the Southern Pacific Railroad. The Santa Fe Route is shown paralleling both (above) to the north.

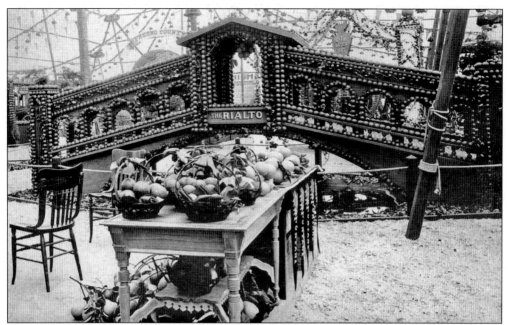

This display was made for the city of Rialto, San Bernardino's neighbor to the west. There are a few stories about how Rialto got its name. One is that it was named after the Rialto Bridge located in Venice, Italy. The design of the city seal still includes this bridge representing a "Bridge of Progress." The population of Rialto in 1911 was 1,500 people.

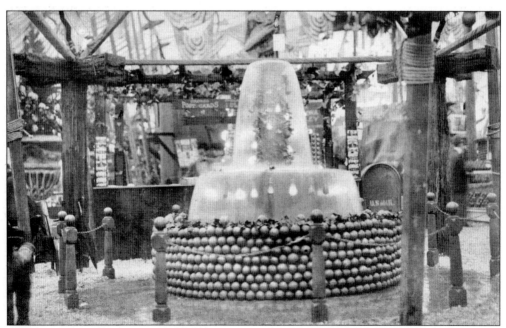

The City of San Bernardino Water Department made this display. It represents one of many artesian wells in the city, similar to the one on page 72. A water company supplied part of the water in the city before 1890, but in that year, bonds were passed, and the water department totally replaced the existing water system with new water mains from a new reservoir.

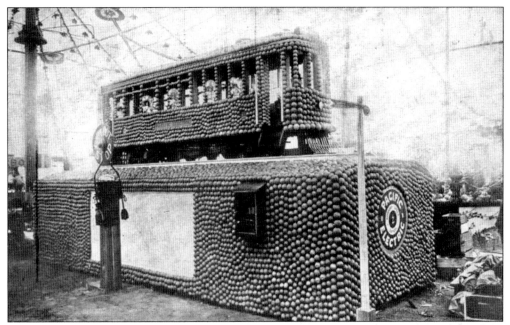

The Pacific Electric Railway built this display. During this time, they called themselves the "World's Greatest Electric Transportation System." They had over 1,000 miles of trolley track to all the points of interest in Southern California. They offered comfort, speed, safety, and convenience. Their motto was "To where you want to go, when you want to go."

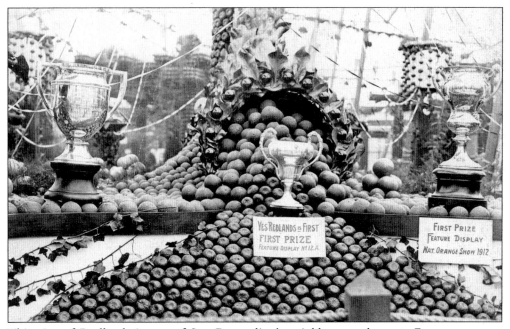

This city of Redlands is one of San Bernardino's neighbors to the east. For many years, Redlands was a leader in production and packing of oranges. This image from 1912 shows the quality trophies that were given for first place. It appears that Redlands won at least two first-place trophies and possibly a third.

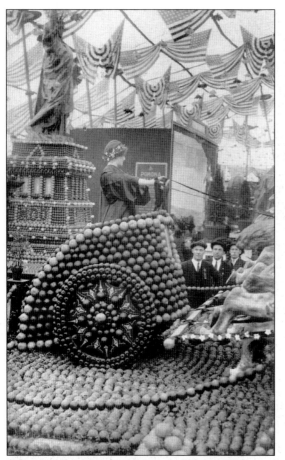

For many years, each Orange Show seemed to outdo the year before. In the first show in 1911, there were 100 boxes of fruit on display with an attendance of 3,000 people. By 1920, there were thousands of boxes of fruit with an attendance of 150,000 people. The displays kept getting more extravagant as well. Similar to the Rose Parade, where all the floats are covered in flowers, the Orange Show displays were almost completely covered with citrus fruit. The location of the event changed from Fourth and E Streets in 1911 to Second and E Streets in 1912 through 1916. It rained during the Orange Show at least once every year from 1911 until 1923, except for one year.

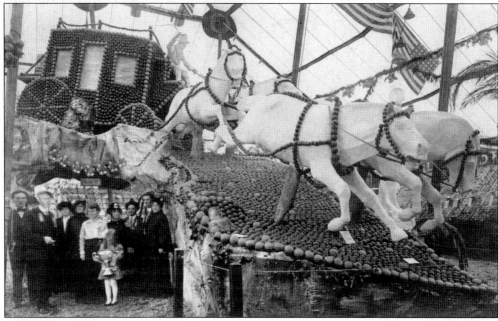

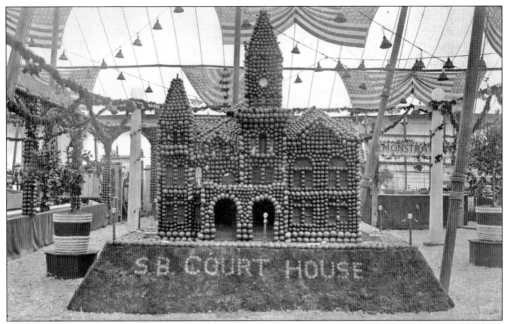

The San Bernardino County Courthouse, built in 1898, was used as a model for an orange display in 1915. The citizens of the city of San Bernardino were very proud of their beautiful courthouse (page 47). It is unknown whether this display was made by the city of San Bernardino, the county itself, or possibly another city in the county.

Although most of the attention was given to citrus displays at the National Orange Show, there were many other things going on. For years, there have been exhibits from children representing every school in the area and personal hobby exhibits. John Tyler from Big Pine wrote on the back of this postcard that his friend Edgar is competing in a woodworking competition at the Sixth National Orange Show in 1916.

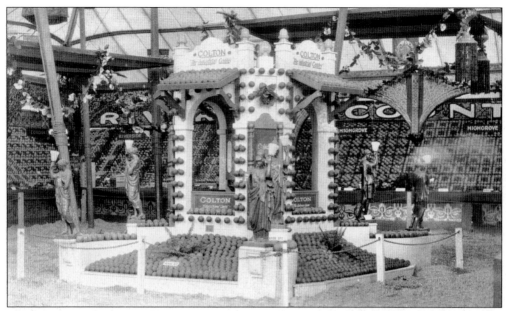

The city of Colton is San Bernardino's neighbor to the southwest and is also the oldest neighbor, becoming a city in 1875. While this card promotes Colton as the "Industrial Center," a fruit exchange started in 1892. There were several packinghouses in Colton, and a large amount of fruit was handled there every year.

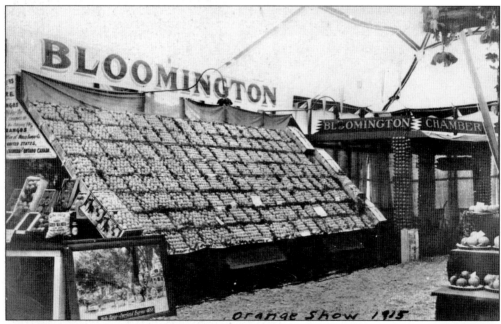

The community of Bloomington is another neighbor to the southwest, but does not share a border with San Bernardino. Early in the town's history, in 1887, the crops of choice were peaches, apricots, grapes, and olives. By the time of the first Orange Show, citrus had taken over as the leading crop, with lemons doing the best.

108

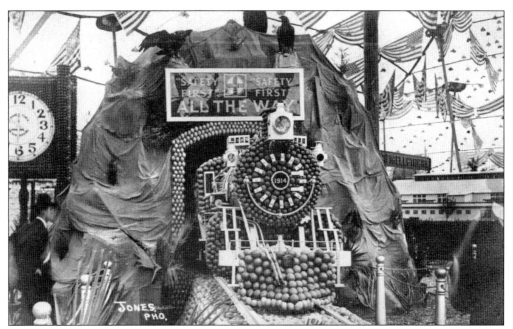

The Santa Fe Railroad has always played a large part in San Bernardino, ever since the first train rolled through in 1883. Affordable travel from it and the Southern Pacific Railroad was the most important factor in the rapid growth of San Bernardino and Southern California. The Santa Fe also played a huge part in the employment of many people. For years, almost every family living in the city had a family member employed by Santa Fe. These two views from 1914 show both the front and the back of the train in a tunnel with the slogan "All the Way with Santa Fe." Santa Fe contributed to almost every parade and festival in the city's history. For the Centennial Celebration in 1910, they converted an automobile into a locomotive, coal car, and passenger Pullman car.

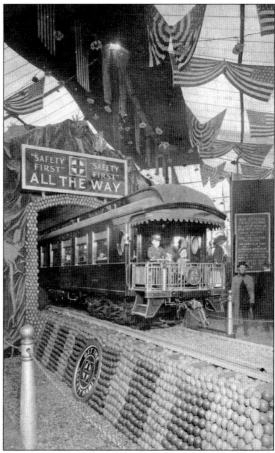

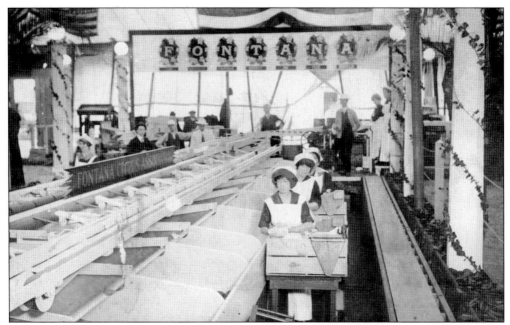

At most of the early Orange Shows, oranges were available for purchase and could be shipped anywhere in the United States. The packinghouse was located on the show grounds, and many growers participated. This image shows the Fontana section of the operation. There were at least three custom crate labels made specially that read "National Orange Show." From 1911 until 1970, the Orange Show was held in either February or early March. This was still winter for most of the nation. To receive a fresh box of California oranges while one still had snow outside in the East was a real treat. For many years, the Orange Show was called "California's Greatest Midwinter Event." Small wooden crate–type boxes with orange balls of candy were also available for kids to mail to their friends.

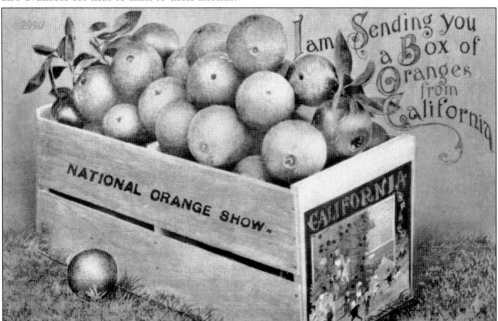

The themes of the displays changed radically during the years of World War I. The seventh show, in 1917, had examples of the different types of weaponry used at the time. This image from San Bernardino County shows an authentic-looking tank. American tanks were very scarce in World War I, so it's doubtful if it's real. The Arrowhead-shaped sign simply says "Steadily Forging Ahead."

In 1918, there was a debate about whether to hold the eighth show. It was decided to carry on with the show in a subdued way. This Riverside display has a replica of the naval ship USS *California* and highlights the fact that Riverside is the home of the navel orange. The "Dove of Peace" in every feature dominated the Ninth Orange Show in 1919.

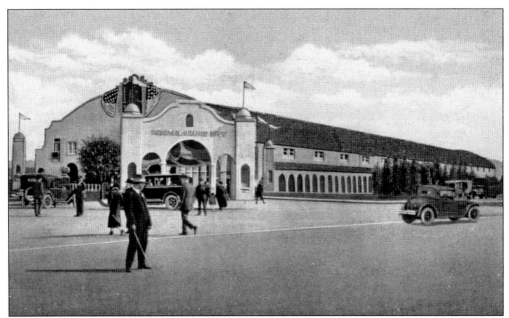

In 1924, the Orange Show had to close one day early because of cyclonic winds blowing away just about everything but the big-top tent. Property damage was over $150,000. Shortly after it closed, it was decided to issue bonds for the construction of a new exhibit building. In February 1919, the 15th National Orange Show opened, and California governor F. William Richardson dedicated the new building.

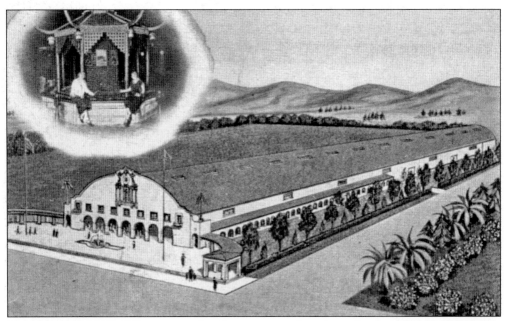

The new $150,000 building was made of concrete, steel, and mostly wood. It was almost two city blocks long at 800 feet, 125 feet wide, and 52 feet high. It had almost 100,000 square feet of floor space with no pillars or posts in the way. It was the largest structure of its type in California. Sadly, in July 1949, it was completely destroyed by fire.

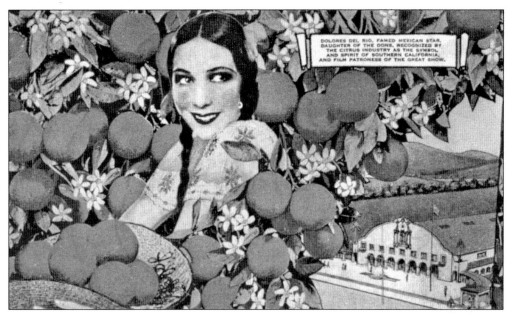

In 1929, Dolores Del Rio was admired as one of the most beautiful women on screen, and she had a flourishing career until the end of the silent era with successful films such as *Resurrection*, *Ramona*, and *Evangeline*. The citrus industry also recognized the famed Mexican star as the symbol and spirit of Southern California that year.

Art deco was a popular design movement from 1920 until 1939. In the mid- to late 1920s, it was starting to catch on at the National Orange Show. It was predominately related to the graphic arts, as seen in these next few postcards. Some of the programs designed during these years had the art deco style. This was one of the last Orange Show postcards distributed before the Great Depression.

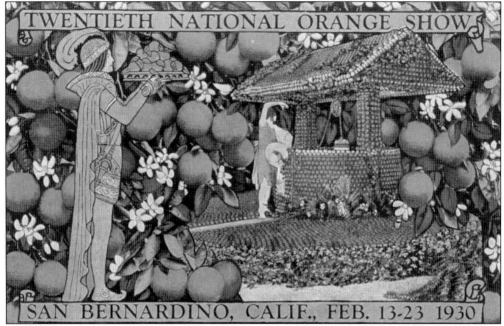

The art deco movement was a huge influence in this card done in 1930. The Great Depression began less than four months before the start of the 20th National Orange Show. This card also had a preprinted message on the back to try to encourage shoppers to visit the Katz Building on Third Street. There's no doubt that stores like that were hurting for business.

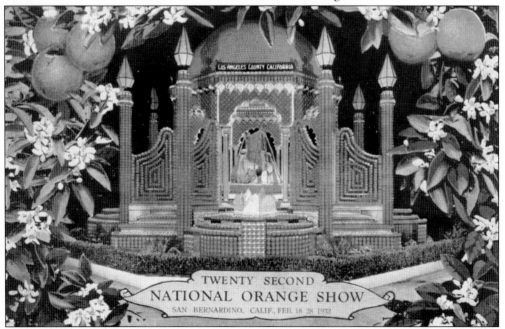

In 1932, this card had a dual purpose. Obviously the beautiful display made by Los Angeles County was advertising the 22nd National Orange Show on the front of the card. The back of the card was advertising the upcoming Olympic Games of 1932 held in Los Angeles. The Orange Show in 1932 also commemorated the 200th anniversary of the birth of George Washington.

The 32nd National Orange Show took place in 1947. Five Orange Show dates were cancelled because of World War II. In 1941, the San Bernardino Air Depot was activated, and the National Orange Show became the home for supplies, the post exchange, transportation, a troop training area, and the station hospital. This image shows the marquee for the 40th show in 1955, which most baby boomers from San Bernardino remember.

A fire in July 1949 destroyed the large exhibition hall. By March 1950, a new and larger steel-and-concrete exhibition building was ready for use. Two other steel buildings similar to this were built before the 1951 show. A building was constructed for commercial and industrial exhibits, and another one was built for feature exhibits and stage shows. It was named after state senator Ralph E. Swing.

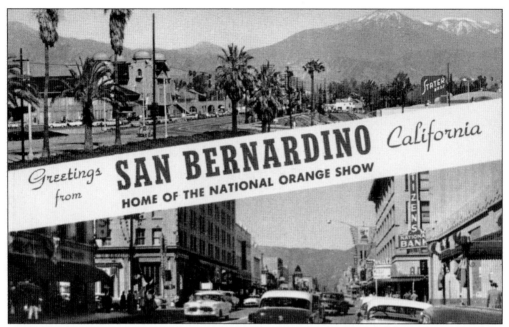

From the late 1950s, this postcard promotes San Bernardino as the "Home of the National Orange Show." It shows the Santa Fe depot with snow-capped mountains in the distance and downtown San Bernardino looking north up E Street from about Third Street.

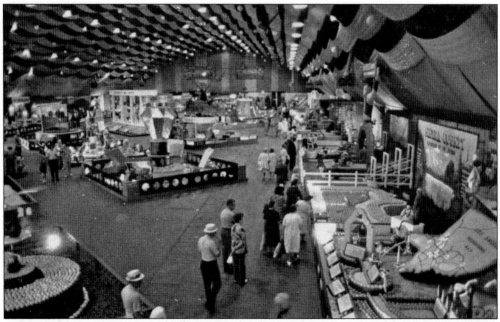

Most of the interiors of the new buildings looked similar. In the Swing Auditorium, it was slightly different than the postcard shows here. The Swing Auditorium had a permanent stage. In 1964, the Rolling Stones made their United States debut on that stage. This building was destroyed on September 11, 1981, when an airplane crashed into it, which strangely coincided with the events of September 11, 2001, twenty years later.

Eight
ROUTE 66 AND BEYOND

The Wigwam Motel was built in the city limits of San Bernardino, although it later acquired a Rialto mailing address. It is on Foothill Boulevard, also known as Route 66, and was built in 1949. There were a total of seven Wigwam Motels built in the United States. Only two other examples of these icons of Route 66 exist today.

The Motel San Bernardino was a little east of the Wigwam Motel on Foothill Boulevard or Route 66. The Route 66 Rendezvous has been held in the city of San Bernardino every year since the first one in 1990, which was held at Glen Helen Park, just north of the city limits. In 2006, attendance was estimated at over 500,000 people over the four-day event.

The Mount Vernon Auto Motel was on Route 66 on Mount Vernon Avenue close to where it turns into Cajon Boulevard. Cajon Boulevard was also part of old Highway 395 that went north and south through the Cajon Pass. The entire Highway 395 stretched from San Diego, California, to Spokane, Washington.

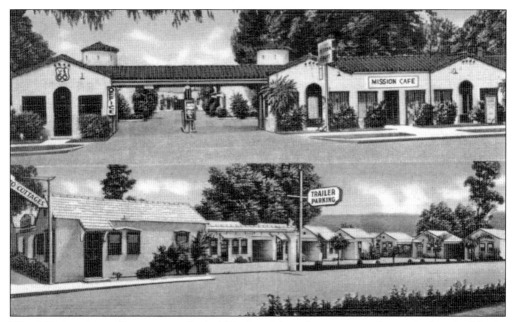

The Mission Auto Court was a beautiful, Spanish-style structure that was also on Mount Vernon Avenue about halfway between Cajon Boulevard and Foothill Boulevard, which in San Bernardino is Fifth Street. Each of the 60 units had a garage for visitors' cars.

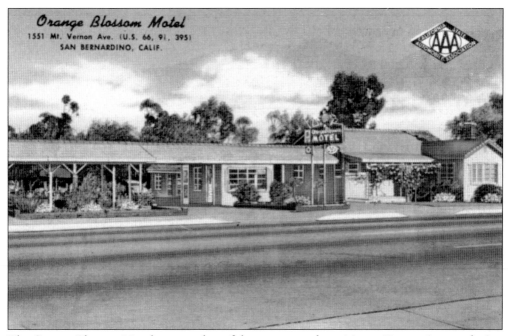

The Orange Blossom Motel was another of the many motels on Mount Vernon Avenue during the heyday of Route 66. This card also advertises the fact that it's part of Highway 395 and State Route 91, which basically started in Long Beach, went through Riverside and San Bernardino, and carried on to the desert and eventually to Nevada.

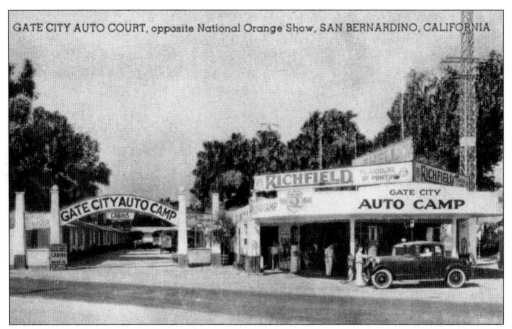

The Gate City Auto Court was across the street from the National Orange Show. The title "Gate City" was a nickname given to San Bernardino after construction of the new Santa Fe depot in July 1918. The *San Bernardino Daily Sun* declared, "Santa Fe's new station to be the finest in the West." The paper gave "Credit to San Bernardino showing importance of the Gate City as a transportation center."

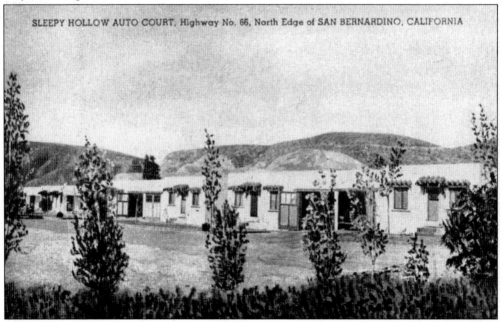

The Sleepy Hollow Auto Court was in north San Bernardino on E Street where it turns into Kendall Drive. This was also known as Alternate Route 66 because it branched off of Cajon Boulevard and came into San Bernardino about three miles east of where Cajon Boulevard turned into Mount Vernon Avenue.

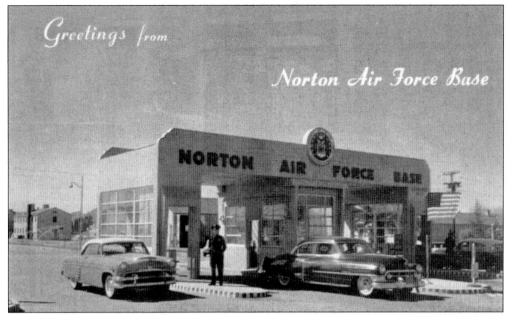

Before Norton Air Force Base got its name, it was known as Municipal Airport, San Bernardino, and was under the Army Air Corps jurisdiction. In the summer of 1941, it was a base for a pilot training program. In December 1941, within days after the attack on Pearl Harbor, combat-ready fighter planes arrived to protect the Los Angeles–San Bernardino area from enemy attack.

In July 1942, the airport was renamed San Bernardino Air Depot. The facility's primary function was the repair and maintenance of aircraft. In 1950, it was renamed Norton Air Force Base after Capt. Leland Norton, a San Bernardino native and World War II bomber pilot who, on his 16th mission over France, ordered the crew of his crippled plane to bail out just before perishing with the craft.

In 1966, Norton Air Force Base became the home for the 63rd Military Airlift Wing, providing airlift and food services to worldwide air and ground combat units. Operations expanded to provide maintenance, storage, and logistics support for various missile programs. The base was selected for closure by the Base Realignment and Closure Commission in 1988 and closed in March 1994.

San Bernardino has been honored to have three naval ships use its name. The first was a patrol craft used only during World War II. The second was a LST, or a tank landing ship, used only with the name from 1955 until 1958. The third, shown here, was LST-1189, commissioned in 1971. When it was decommissioned in 1995, the bell was given to the city of San Bernardino.

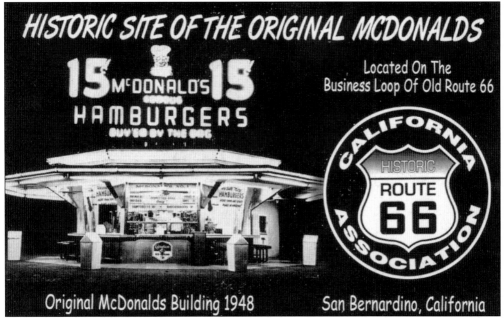

Two brothers, Richard and Maurice McDonald, had a popular restaurant in San Bernardino called McDonald's Barbeque Restaurant in 1940. It soon became a popular teen hangout. In 1948, Richard studied sales receipts and discovered that 80 percent of their sales were hamburgers. In December 1948, they opened the original McDonald's restaurant featuring their "Speedee Service System" selling 15¢ hamburgers and 10¢ fries. In 1954, a local milk shake equipment salesman named Ray Kroc made a deal with the McDonald brothers to franchise their restaurant and system. In 1961, Kroc bought out the two brothers for $2.7 million. Unfortunately that building was demolished in 1972. Today a new building is on the original site and operates the McDonald's Museum. The McDonald's Corporation does not recognize this location as their first restaurant because Ray Kroc didn't own it.

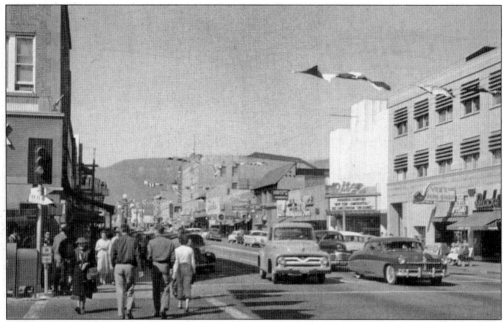

Both of these images seem to have been taken on the same crystal-clear day. The movie advertised on the Ritz Theater (above), *New York Confidential*, was released in February 1955, which also fits with the automobiles shown. Judging by the banners hanging across the streets, it looks like San Bernardino was experiencing a moderate Santa Ana condition that day. The Santa Ana is a warm, dry wind blowing from the east and northeast. It is dried and heated when it is compressed through the mountain passes on its way to the Pacific Coast. At times, in some areas, it can be very windy, but for most people the crisp, clear days are worth it. The top postcard is looking north up E Street from Fourth Street. The card below is looking north up F Street from Third Street.

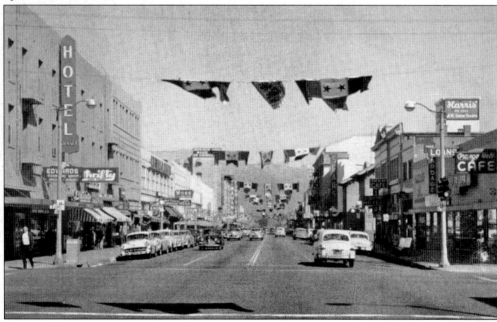

Greetings from **SAN BERNARDINO, CALIFORNIA**

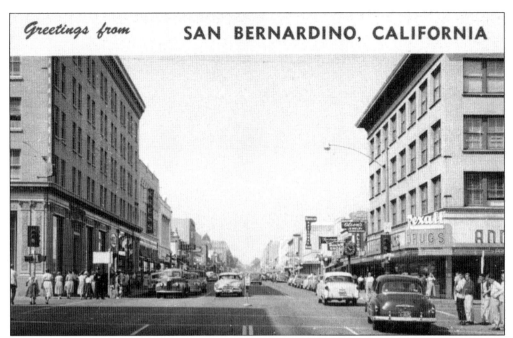

This view, again in the 1950s, is looking north up E Street from Third Street in front of the Harris Company, which is not visible. On the left is the Bank of America in the Andreson Building. It is a different building than on page 14, but the same family built it. People used to come from all over to shop in downtown San Bernardino.

There were large department stores in San Bernardino that the smaller, surrounding cities did not have, unlike today. F&W Woolworth Company on the right was just such a store. Starting in the 1960s when this image was taken, enclosed shopping malls were becoming very popular even in a city like San Bernardino that had great weather most of the time. That trend now appears to be reversing.

This aerial view shows San Bernardino from the extreme south end looking north. The Inland Center Mall is the large complex at the bottom. This is the same area in which Urbita Springs Park was located (pages 76–79) less than a century before. This mall was built in 1967. This view appears to be pre-1972, before the Central City Mall was built downtown.

This appears to be a fairly recent view of downtown San Bernardino looking south from the 13-story Caltrans Center building. The building on the right is the Clarion Hotel at Third and E Streets and is in the same place where the Stewart Hotel stood well over a century ago (pages 29 and 30). City hall is in the middle, and the Vanir Tower is to the left.

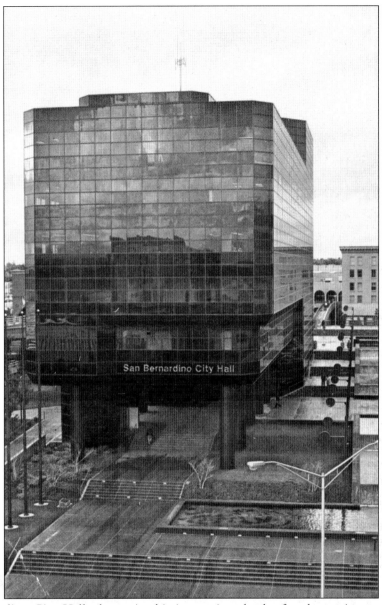

San Bernardino City Hall, shown in this image, is only the fourth one in over 150 years after the city was incorporated in 1854. Since its completion in 1972, it has received praise from architectural journals worldwide. A young Cesar Peli, now a world-renowned architect, is know to have collaborated on this project. Designed by the architectural firm of Gruen Associates, the outside of the building is covered with 6,000 tinted smoked-glass windows covering 90 percent of the exterior. In 1982, the American Institute of Architects selected the San Bernardino City Hall as a modern, super-high-tech example of the 20th century. From inside, views of the city and the mountains are spectacular. Adjacent to city hall is the San Bernardino Convention Center with matching smoked-glass exterior. It has over 17, 000 square feet of meeting rooms, including a ballroom, all of which is serviced by the Clarion Hotel. On the north side of city hall is an 11-foot-tall statue of Martin Luther King that was placed there in 1981.

Across America, People are Discovering Something Wonderful. *Their Heritage.*

Arcadia Publishing is the leading local history publisher in the United States. With more than 4,000 titles in print and hundreds of new titles released every year, Arcadia has extensive specialized experience chronicling the history of communities and celebrating America's hidden stories, bringing to life the people, places, and events from the past. To discover the history of other communities across the nation, please visit:

www.arcadiapublishing.com

Customized search tools allow you to find regional history books about the town where you grew up, the cities where your friends and family live, the town where your parents met, or even that retirement spot you've been dreaming about.